AMERICAN POETS PROJECT

AMERICAN POETS PROJECT

IS PUBLISHED WITH A GIFT IN MEMORY OF

James Merrill

AND SUPPORT FROM ITS FOUNDING PATRONS

Sidney J. Weinberg, Jr. Foundation

The Berkley Foundation

Richard B. Fisher and Jeanne Donovan Fisher

Cole Porter

selected lyrics

robert kimball editor

AMERICAN POETS PROJECT

THE LIBRARY OF AMERICA

Lyrics used by permission of Warner/Chappell Music, Alfred Publishing Co., Inc., and the Cole Porter Musical and Literary Property Trusts, Peter L. Felcher, Trustee. See page 166 for further copyright information.

Special thanks to Peter L. Felcher, Roberta Staats, and Jay Morgenstern.

The paper used in this publication meets the requirements of ANSI/NISO Z39.48–1992 (Permanence of Paper).

Frontispiece: AP/Wide World Photos

Library of Congress Control Number: 2024943800
ISBN: 978–1–59853–794–9

First paperback printing – November 2024

10 9 8 7 6 5 4 3 2 1

Cole
Porter

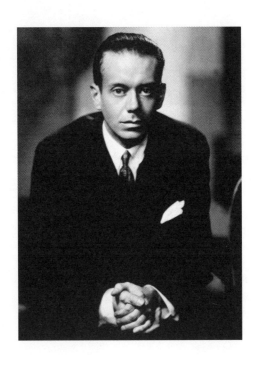

CONTENTS

INTRODUCTION

More than 12 years elapsed between Cole Porter's first
Broadway show, *See America First* (1916), a short-lived at-
tempt to Gilbert and Sullivanize the American musical,
and his triumph in 1928 with the songs for the Irene Bor-
doni show *Paris*, notably the slyly insinuating "Let's Do
It." If one song could be said to have put Porter on the
map to stay, it was that refreshingly unabashed ode to the
joys of sex. He was already in his late 30s. What had taken
him so long?

One possible explanation was offered by his friend and
colleague Irving Berlin, who felt that because Porter had
the gift of writing in almost any style—"It came easy for
him"—he only gradually found his own distinctive, indi-
vidual voice. It was when he began to write from his own
perspective and experience as part of the "lost generation"
of literary exiles in post–World War I Europe that his ca-
reer took flight. In short order Porter found himself not
just an acclaimed songwriter, but something of a symbol
for his era.

If his success seemed to come late, it was only because

his promise had been apparent early on, at least within the family; his mother, who started him off on piano and violin at the age of six and performed humorous renditions for him of popular songs of the day, arranged for the publication of the "Bobolink Waltz" when Porter was 11. (A copy of it is on display in the county museum in Peru, Indiana, where Porter was born on June 9, 1891.) Such juvenilia aside, Porter's earliest surviving compositions date from 1910. He had begun writing songs while still a prep-school student at Worcester Academy in Massachusetts. During his years at Yale, 1909–1913, he honed his craft working on Glee Club and football songs, and, most important, musical comedy scores for his fraternity, Delta Kappa Epsilon, and for the annual productions of the undergraduate Yale Dramatic Association.

Given his accomplishments at Yale, a successful Broadway career seemed open to him, but there were detours along the way. In 1917 Porter sailed to France to participate in relief work on the western front; and in 1918, while living in Paris, he met the beautiful, wealthy, Louisville-born divorcée Linda Lee Thomas, eight years his senior, whom he married a year later. Their remarkable marriage and close friendship lasted until Linda's death in 1954. Porter also had relationships with several male companions —usually with Linda's approval. It was Linda's faith in him and his talent that sustained him during his years of struggle, and he was visibly overwhelmed by grief at her funeral.

Throughout the 1920s Porter continued to contribute songs to musical revues, without notable success until the triumph of *Paris*. The risqué elegance of his songs seemed a perfect complement to the boom times of the Jazz Age, yet it was the Depression years that followed that were to be Porter's greatest and most productive decade, a period during which half of all his standards were written. Born to wealth, a habitué of the most exclusive international social

set, Porter would become an artist who spoke to audiences worldwide. Perhaps his world-weariness, his somewhat jaded take on affluence and high society, took on a deeper resonance after the crash of 1929.

Porter connected with audiences above all by how tellingly, within the limits of popular song, he could write about emotional relationships and their transient nature. His songs were at home with the extremes of passion—

> So taunt me and hurt me,
> Deceive me, desert me,
> I'm yours 'til I die,
> So in love,
> So in love,
> So in love with you, my love, am I.

—and the moods of loss that might follow:

> So goodbye, dear, and amen.
> Here's hoping we meet now and then,
> It was great fun,
> But it was just one of those things.

Passion and loss are inextricably intertwined in "In the Still of the Night," an extraordinary demonstration of Porter's technical dexterity:

> Oh, the times without number,
> Darling, when I say to you,
> "Do you love me as I love you?
> Are you my life-to-be, my dream come true?"
> Or will this dream of mine
> Fade out of sight
> Like the moon
> Growing dim
> On the rim
> Of the hill

In the chill,
Still
Of the night?

The intensity of his love lyrics, the penetration of their insights into the complexity of human relationships, are among the qualities that distinguish his bravest and best work. There was also the sheer effervescence of his humor, the brilliantly uplifting high spirits of a song like "You're the Top"; his brand of civilized entertainment was a perfect tonic for the times, a lilting companion to the recently legalized cocktail. The ultimate effect was a bittersweet mixture distinctly his own. In the words of songwriter Alec Wilder: "The light touch, the mordant turn of phrase, the finger-tip kiss, the double entendre, the awareness of the bone-deep fatigue of urban gaiety, the exquisite, and the lacy lists of cosmopolitan superlatives—these were the lyrical concerns of Cole Porter."

To separate Porter's lyrics from his music is of course to provide only a partial impression of these songs, particularly because words and music were so intimately linked in his creative process. Usually he began with a title or an idea—an idea that could be musical or lyrical or both. He would then work from both the beginning and ending of a song, moving in both directions toward the middle. For the most part, he did not create music and lyrics separately, they came together. He worked largely at night, with a rhyming dictionary and other reference books, and he was a tireless reviser and polisher. Obviously, list songs required additional work after the melody was finished. Porter once observed that if, like him, one had comparable facility in writing both music and lyrics, writing lyrics was more difficult.

One of the best examples of Porter's obsessive tenacity when he was working was described by librettist Russel

Crouse: "I'll never forget the day during rehearsals of *Red, Hot and Blue* when he went for an entire day without speaking to me. By the time five o'clock had arrived, I was sure I had offended him and had lost a friend. I was just about to open negotiations for a restoration of an *entente cordiale* when he came up to me, looked me square in the eye, and said: 'In my pet pailleted gown.'" The "pet pailleted gown" is but one phrase in the evocative opening of "Down in the Depths," an opening that captures the contrast between a nocturnal city in full, festive celebration and a despondent, affluent solitary:

> With a million neon rainbows burning below me
> And a million blazing taxis raising a roar
> Here I sit, above the town
> In my pet pailleted gown
> Down in the depths on the ninetieth floor.

"Places have always inspired my writing," Porter told his first biographer, Richard Hubler, in 1954. From the time as a boy when he had first seen in his hometown, Peru, Indiana, a theater curtain with a "fantastic painted view of the Grand Canal," travel became a powerful stimulus to his life and work and spurred his life journey: from Indiana to Chicago; Worcester, Massachusetts (where he went to prep school); New Haven and Yale College; the Harvard Law and Music schools. From there he went on to New York's Greenwich Village, Europe's western front during World War I, and of course to Paris, his home for two decades and his frequent inspiration, from his first major triumphs, *Paris* (1928) and *Fifty Million Frenchmen* (1929), to his last shows, the Paris-based Broadway scores *Can-Can* in 1953 and *Silk Stockings* in 1955. There were also the Riviera, Egypt, Spain, his beloved Venice and other Italian cities, cruises galore, a trip around the world and

back to New York and Hollywood. It was an odyssey that enriched his life and his songs.

He already had enjoyed two trips to Europe before he wrote his first, albeit minor hit, "I've a Shooting Box in Scotland." "Weren't We Fools" was written in Venice for Fanny Brice. "What Is This Thing Called Love?" was shaped in part by the sound of drummers in a square in Marrakech, Morocco. A night walk in London led to "Love for Sale." He wrote "Night and Day" on a beach in Newport, Rhode Island; "Just One of Those Things" was crafted literally overnight on a farm outside Cleveland, Ohio. He composed "You're the Top" while floating along the Rhine River in a *faltboat*, after a party. His friend Baron Nicolas de Gunzburg, who was present on the Rhine trip, recalled that Porter "had asked us to tell him what we considered the top." "It's De-Lovely" was brought to life (according to contradictory accounts, both provided by Porter) either by a dawn view of Rio de Janeiro's harbor or by the pleasure of eating the Eastern fruit mangosteen on the island of Java. "Begin the Beguine" was inspired by a native dance in the village of Kalabahai on the island of Alor in the Dutch East Indies.

Exotic contrasts, the juxtaposition of extremes, the pitting of high culture against low and vulgarity against refinement, all come to the fore again and again in his lyrics: "Will it be Bach I shall hear or just a Cole Porter song" . . . "From the heights of Valhalla to Kalamazoo" . . . "You're a Botticelli, you're Keats, you're Shelley, you're Ovaltine." Contrasts were also at the heart of many of his shows. The settings of his 1939 musical *Du Barry Was a Lady* range from the court of Louis XV to the men's washroom of a nightclub on Manhattan's West 52nd Street. *Kiss Me, Kate*'s action went back and forth between a production of Shakespeare's *Taming of the Shrew* and the backstage and alley of a post–World War II Baltimore theater; and in

Out of This World, the show that followed *Kate*, Porter delineated the byplay between honeymooning American mortals and ancient Greek gods.

His relish for variety is also evident in his cherished list songs, which amount to a catalogue of the times in which he lived and worked, replete with the catch phrases, celebrities, and scandals of the day. Like the most famous of them, "You're the Top," they tend to be merry, carefully researched, skillfully rhymed romps through history and geography. (In a number such as "Let's Not Talk About Love," Porter delivers a more than casual bow to Gilbert and Sullivan's "My Name Is John Wellington Wells" from *The Sorcerer*.) All in all, his list songs are among the richest in surprise and virtuosity; only their length limited the number that could be included in this collection.

Although Porter was no moral crusader, he became something of an inadvertent hero in the struggle against censorship in America. On many occasions his songs came up against the limits of what was deemed appropriate. The second verse to "I'm Unlucky at Gambling" had a reference to homosexuality, and although sung in the show *Fifty Million Frenchmen*, that verse was not included in the published sheet music. "The Tale of the Oyster," also from *Frenchmen*, was quickly dropped after the New York opening because some critics thought that for all its wit, it was in poor taste to present a song about regurgitation. Most famously, the lyric from "Love for Sale," from *The New Yorkers*, could not be sung on the radio for many years because of its subject matter. Objections to early performances of the song forced Porter and book writer Herbert Fields to change the scene in which it was presented in the show from "in front of Reubens'" to the "Cotton Club, Lenox Avenue, Harlem" and the singer to "a colored girl." Four years after the line "Some get a kick from cocaine," from "I Get a Kick Out of You," was quickly subjected to the blue

pencil and replaced by such alternatives as "Some like the perfumes of Spain" and "Some like a bop-type refrain."

At the end of the 1930s, "But in the Morning, No" (virtually unknown until Ben Bagley rediscovered it in the 1960s) was also barred from the airwaves. It had to be "cleaned up" for performances in Boston, and it was published with a single edited refrain that had no double entendres; in some places a recording was removed from the shelves of record stores. The censors were still active even as late as 1950, when the show *Out of This World* played Boston and objection was raised to the line "Nobody's goosing me" in the song "Nobody's Chasing Me." Thanks to Porter's risk-taking, future songwriters may have had an easier time of it.

Despite the considerable success he enjoyed throughout his career, Porter was sometimes criticized for letting his standards slip. Part of what was at issue may have been the fact that he was writing for a Broadway whose audience had changed, and for Hollywood films whose producers encouraged a more accessible vein. After *Jubilee* (1935)—a relatively unsuccessful show despite such songs as "Begin the Beguine" and "Just One of Those Things"—he began thinking out loud about the kinds of songs he was writing for Broadway. In 1936 he told an interviewer that "sophisticated allusions are good for about six weeks. Futile as presenting Sophocles in the original Greek. Audience reaction to Lady Mendl lasts about eight weeks. Sophisticated lyrics are more fun, but only for myself and about 18 other people, all of whom are first-nighters anyway. Polished, urbane, and adult playwriting in the musical field is strictly a creative luxury."

Perhaps it should be no surprise that in *Red, Hot and Blue* (1936), the suave "You're a Bad Influence on Me" was replaced by "The Ozarks Are Calling Me Home," and that

for his next assignment, the 1937 film score *Rosalie*, he wrote the "popular" title song to please producer L. B. Mayer. It should be noted, though, that his great stage triumph, *Kiss Me, Kate*, dates from 1948.

The other factor in what some have seen as a falling-off of Porter's creativity was the disaster that marked the dividing point in his life. In the fall of 1937, shortly after he returned to New York following a hiking trip through the Dolomites, Porter joined some friends at the Long Island home of Countess Edith di Zoppola (the former Edith Mortimer). On the morning of October 24, he went riding at the Piping Rock Club and suffered a terrible accident—his horse shied and fell on him. "When this horse fell on me," Porter told an interviewer, "I was too stunned to be conscious of great pain, but until help came I worked on the lyrics for a song called 'At Long Last Love.'" The opening line of the song's refrain is, "Is it an earthquake or simply a shock?"

As Porter later recalled, "I woke up in a local hospital with both legs broken in compound fractures, an important nerve nearly cut in two. From then on I spent months under sedatives. Through the years I underwent 33 bone operations under the jurisdiction of John J. Moorhead, the best bone surgeon we could find." As Porter recuperated, he followed the advice of Dr. Moorhead: "Work! Work! As you've never worked before." "I think it saved my mind as well as my legs," Porter later recalled. "My semi-doped brain seemed to be buzzing with tunes. To keep at my writing, I had my piano raised on wooden blocks and sat at it in a wheelchair." After his right leg was amputated in 1958, Porter never wrote another song.

It has been nearly 50 years since Cole Porter wrote his last song (for the television musical *Aladdin*) and more than

40 since his death in Santa Monica, California, in 1964, at the age of 73. More than 800 of his lyrics survive; he created the scores for more than 35 shows for New York and London and 12 film musicals, and nine of his Broadway shows ran for more than 400 performances, a total that has not been equaled or surpassed by any other writer. His reputation as a composer-lyricist, high during his lifetime, continues to grow and attract an even larger following. He has been the subject of two film biographies. There have been over a dozen Porter song books, including two devoted to previously unpublished works, major recording reissues by, among others, the Indiana Historical Society and the Smithsonian Institution, and important revivals of *Anything Goes* and *Kiss Me, Kate*.

Recordings abound as well by jazz, opera, and cabaret artists, and there are a surprisingly large number of recorded tracks by contemporary pop stars including U2, Deborah Harry, David Byrne, and Annie Lennox (on the 1990 AIDS album *Red, Hot and Blue*) and by Robbie Williams, Sheryl Crow, Diana Krall, Elvis Costello, and Alanis Morissette for the soundtrack of the 2004 Porter film biography *De-Lovely*. While old favorites such as "Night and Day," "In the Still of the Night," and "Begin the Beguine" continue to resonate in the public consciousness, others, less known, such as "After You," "Dream Dancing," and "The Tale of the Oyster" have entered the pantheon of Porter standards. It all confirms the words of the citation that accompanied the honorary degree he received from his alma mater, Yale, in 1960: "You are, in your own words and in your own field, the top."

This volume is dedicated to the memory of the great Porter interpreter Bobby Short.

Robert Kimball
2005

Bull Dog

Way down, way down in New Haven town,
Lives Mister Yale,
Old Eli Yale.
No one ever cares to come around,
Just because of his pet "Bow-wow."
Poor old Harvard tries it once a year,
Always goes back,
Tied up in black,
For when old Yale sicks that big bull dog on,
He raises an awful row.

REFRAIN
Bull dog! Bull dog! Bow, wow, wow,
Eli Yale!
Bull dog! Bull dog! Bow, wow, wow,
Our team can never fail.
When the sons of Eli break through the line,
That is the sign we hail.
Bull dog! Bull dog! Bow, wow, wow,
Eli Yale!

Antoinette Birby

VERSE I
Miss Antoinette Birby lived way out in Derby,
A maid divinely fair.
She found it no heaven retiring at seven;

Her heart was filled with care.
'Twas truly a pity that a maiden so pretty
Should milk the cows all day,
So she took a notion to get into motion
And packed her trunk right away.
As the train pulled out of the station,
She gave forth this explanation:

REFRAIN I

I'm off for New Haven, so long, goodbye,
I'm off for New Haven, I don't know why.
This leaving the family really makes me very sad,
For they are by far the best pa and ma I ever had.
But I've got to sling hash at the Taft Hotel,
As a waitress I never shall fail.
For I have a cravin' for dear old New Haven
And Yale, Yale, Yale.

VERSE 2

Arrived in the city, this maiden so pretty
Did walk down Chapel Street,
And then a young fellow to whom she said "Hello"
Our heroine did meet.
Now he was a villain, but Nettie was willin',
She loved him right away.
Her scruples forsook her,
The villain he took her into a swell café.
As she took down her first few swallows,
She was heard to murmur rather incoherently as follows:

REFRAIN 2

I'm strong for New Haven, believe me, kid,
For this is the town where there ain't no lid.
The life in New Haven makes Derby seem so very tame,
I've learned sev'ral things that I never knew before I
 came.
I'm going to learn all that there is to know,
At least if I keep out of jail,
As a fountain of knowledge believe me some college
Is Yale, Yale, Yale.

VERSE 3

Next morn at eleven, instead of at seven,
She woke up in dismay.
Her bean it was addled, her brain had skedaddled,
For she had passed away.
The warden he brought her a pail of ice water,
Her thirst was so intense;
Her spirit was stricken, her conscience was pricken,
Her head it felt immense
As she left the police station,
She gave out this information:

REFRAIN 3

I'm going back to Derby, so long, goodbye,
I'm going back to Derby, you all know why.
When I came to New Haven I was so very good and
 sweet and true,
But I've done sev'ral things that a girlie shouldn't
 oughta do.
So it's back to the milking for Antoinette,

A sadder but wiser female.
No maiden that's pretty should come to the city
And Yale, Yale, Yale.

I've a Shooting Box in Scotland

Nowadays it's rather nobby
To regard one's private hobby
As the object of one's tenderest affections;
Some excel at Alpine climbing,
Others have a turn for rhyming,
While a lot of people go in for collections.

Such as prints by Hiroshigi,
Edelweiss from off the Rigi,
Jacobean soup tureens,
Early types of limousines,
Pipes constructed from a dry cob,
Baseball hits by Mister Ty Cobb,
Locks of Missus Browning's hair,
Photographs of Ina Claire,
First editions still uncut,
Daily pranks of Jeff and Mutt,
Della Robbia singing boys,
Signatures of Alfred Noyes,
Fancy bantams,
Grecian vases,
Tropic beetles,

Irish laces,
But my favorite pastime
Is collecting country places.

REFRAIN 1
I've a shooting box in Scotland,
I've a château in Touraine,
I've a silly little chalet
In the Interlaken Valley,
I've a hacienda in Spain,
I've a private fjord in Norway,
I've a villa close to Rome,
And in traveling
It's really quite a comfort to know
That you're never far from home!

VERSE 2
Now it's really very funny
What an awful lot of money
On exorbitant hotels a chap can squander;
But I never have to do so,
Like resourceful Mister Crusoe,
I can find a home however far I wander.

REFRAIN 2
I've a bungalow at Simla,
I've an island east of Maine,
If you care for hotter places,
I've an African oasis
On an uninhabited plain;
I've a houseboat on the Yangtse,

I've an igloo up at Nome,
Yes, in traveling
It's really quite a comfort to know
That you're never far from home!

Having lots of idle leisure
I pursue a life of pleasure,
Like a rolling stone in constant agitation.
For tho' stay-at-homes may cavil,
I admit I'd rather travel
Than collect a crop of mossy vegetation!

I've a shanty in the Rockies,
I've a castle on the Rhine,
I've a Siamese pagoda,
I've a cottage in Fashoda,
Near the equatorial line!
On my sable farm in Russia
O'er the barren steppes we'll roam,
And in traveling,
It's really quite a comfort to know
That you're never far from home.

Parody
I've had shooting pains in Scotland,
I've had measles in Touraine,
I've had horrible malaria
When going through Bavaria
That suddenly turned to ptomaine;
I've had Bright's disease in Denmark,

I've had whooping cough in Rome,
But when traveling the Continent
It's pleasant to know
That there's leprosy at home.

War Song

And when they ask us how dangerous it was
We never will tell them, we never will tell them.
How we fought in some café
With wild women night and day—
'Twas the wonderfulest war you ever knew.
And when they ask us, and they're certainly going to
 ask us,
Why on our chests we do not wear the Croix de Guerre,
We never will tell them,
We never will tell them,
There was a front, but damned if we knew where.

Old-Fashioned Garden

VERSE
One summer day I chanced to stray
To a garden of flow'rs blooming wild,
It took me once more to the dear days of yore
And a spot that I loved as a child.
There were the phlox,

Tall hollyhocks,
Violets perfuming the air,
Frail eglantines,
Shy columbines,
And marigolds everywhere.

It was an old-fashioned garden,
Just an old-fashioned garden,
But it carried me back
To that dear little shack
In the land of long ago.
I saw an old-fashioned missus
Getting old-fashioned kisses,
In that old-fashioned garden
From an old-fashioned beau.

When I Had a Uniform On

Now since the Allied banners
Gave a lesson in good manners
To the Kaisers and crown princes,
And von Hindenburgs, von Ludendorffs,
Von Falkenhayns, von Mackensens,
Von Tirpitzes, von Klucks,
The youth of all the nations
Finds its greatest recreations
Drinking Pol Roger and Pommery,

Veuve Clicquot, Louis Roederer,
Ruinart, Piper Heidsieck,
Montebello, Mumm's and Cook's,
But while I watch the other fellows throwing up their
 hats,
And crying that at last the world's made safe for
 democrats,
For me the road seems rocky,
For they've stripped me of my khaki,
And since I've been demobilized

REFRAIN
I find that life's not what it used to be
When I had a uniform on,
For all the lovely ladies fell for me
When I had a uniform on.
And in those days of glory I was the beau
Of ev'ry doggone musical show.
Each night you'd see me supping somewhere
With a dainty little star upon my Croix de Guerre.
Into their inmost hearts they'd let me strike
When I had a uniform on.
But now the war is o'er
They don't quite like me anymore,
And it's a bore.
For they used to bound around me in millions,
But now, somehow that I'm in civilians,
They pass me by.
Gee, I wish I
Could start another war.

Two Little Babes in the Wood

Listen, my children, and don't say a word.

Now, you'll grant me that Denmark has ne'er had a
 grander son,
Than her great author, old Hans Christian Andersen.
All of you know him, so just to be good to you,
I'll tell his tale of the Babes in the Wood to you.

VERSE I
There's a tale of two little orphans who were left in their
 uncle's care,
To be reared and ruled and properly schooled
Till they grew to be ladies fair.
But, oh, the luckless pair!
For the uncle, he was a cruel trustee,
And he longed to possess their gold;
So he led them thence to a forest dense,
Where he left them to die of cold.
That, at least, is what we're told.

REFRAIN I
They were two little babes in the wood,
Two little babes, oh, so good!
Two little hearts, two little heads,
Longed to be home in their two little beds,
So—two little birds built a nest
Where the two little babes went to rest,
While the breeze, hov'ring nigh,

Sang a last lullaby
To the two little babes in the wood.

PART II. ANNOUNCEMENT.
Listen, my children, and don't say a word.

Now in spite of all efforts to strengthen and quicken it,
Andersen's tale never had any kick in it.
So his descendant, John Murray, in fantasy,
Added a scene for the tired businessman to see.

VERSE 2
They were lying there in the freezing air,
When fortunately there appeared
A rich old man in a big sedan,
And a very, very fancy beard.
He saw those girls and cheered,
Then he drove them down to New York town,
Where he covered them with useful things,
Such as bonds, and stocks, and Paris frocks,
And Oriental pearls in strings,
And a showcase full of rings.

REFRAIN 2
Now those two little babes in the wood,
Are the talk of the whole neighborhood,
For they've too many cars, too many clothes,
Too many parties, and too many beaux,
They have found that the fountain of youth
Is a mixture of gin and vermouth,
And the whole town's agreed
That the last thing in speed
Is the two little babes in the wood.

I'm in Love Again

Why am I
Just as happy as a child?
Why am I
Like a racehorse running wild?
Why am I
In a state of ecstasy?
The reason is 'cause
Something's happened to me.

I'm in love again
And the spring is comin',
I'm in love again,
Hear my heart strings strummin',
I'm in love again,
And the hymn I'm hummin'
Is the "Huddle Up, Cuddle Up Blues!"
I'm in love again,
And I can't rise above it,
I'm in love again,
And I love, love, love it:
I'm in love again,
And I'm darn glad of it,
Good news!

Someone sad,
Had the awful luck to meet,
Someone bad,

But the kind of bad that's sweet.
No one knows
What a glimpse of paradise,
Someone who's naughty
Showed to someone who's nice.

I'm in love again,
And with glee I bubble.
I'm in love again,
And the fun's just double.
I'm in love again.
If I got in trouble,
I'll be cursin' one person I know.
I'm in love again,
I'm a lovebird singin',
I'm in love again.
I'm a spring lamb springin',
I'm in love again,
Weddin' bells are ringin',
Let's go.

Let's Misbehave

VERSE
You could have a great career,
And you should.
Only one thing stops you, dear,
You're too good.

If you want a future, darling,
Why don't you get a past?
'Cause that fatal moment's coming,
At last.

We're all alone
No chaperon
Can get our number,
The world's in slumber,
Let's misbehave.
There's something wild
About you, child,
That's so contagious,
Let's be outrageous,
Let's misbehave.
When Adam won Eve's hand,
He wouldn't stand for teasin',
He didn't care about
Those apples out of season.
They say that spring
Means just one thing
To little love birds,
We're not above birds,
Let's misbehave.

It's getting late
And while I wait,
My poor heart aches on,
Why keep the brakes on?

Let's misbehave.
I feel quite sure,
Un peu d'amour
Would be attractive,
While we're still active,
Let's misbehave.
You know my heart is true,
And you say, you for me care;
Somebody's sure to tell,
But what the hell do we care?
They say that bears
Have love affairs,
And even camels;
We're merely mammals,
Let's misbehave.

The Laziest Gal in Town

VERSE

I've a beau, his name is Jim,
He loves me and I love him,
But he tells me I'm too prim,
That means I'm too slow.
I let him rant, I let him rave,
I let him muss my permanent wave,
But when he says "Let's misbehave,"
My reply is "No!"

It's not 'cause I wouldn't,
It's not 'cause I shouldn't,
And, Lord knows, it's not 'cause I couldn't,
It's simply because I'm the laziest gal in town.
My poor heart is achin'
To bring home the bacon,
And if I'm alone and forsaken,
It's simply because I'm the laziest gal in town.
Though I'm more than willing to learn
How these gals get money to burn,
Ev'ry proposition I turn down,
'Way down,
It's not 'cause I wouldn't,
It's not 'cause I shouldn't,
And, Lord knows, it's not 'cause I couldn't,
It's simply because I'm the laziest gal in town.

VERSE SUNG BY MARLENE DIETRICH

Nothing ever worries me,
Nothing ever hurries me.
I take pleasure leisurely
Even when I kiss.
But when I kiss they want some more,
And wanting more becomes a bore,
It isn't worth the fighting for,
So I tell them this:

Weren't We Fools?

Ev'ry time I see you, dear,
I think of days when you were near,
And I held you close to my heart.
Life was like a perfect dream
And yet so real it didn't seem
That we two could ever drift apart.
I know that all you said to me was true,
And you love me still
As I love you.

REFRAIN

Weren't we fools to lose each other?
Weren't we fools to say goodbye?
Tho' we knew we loved each other,
You chose another.
So did I.
If we'd realized our love was worth defending
Then the story's broken threads we might be mending
With perhaps a diff'rent ending,
A happy ending.
Weren't we fools?
Weren't we fools?

VERSE 2

Think of all the plans we made,
The schemes we had,
The plots we laid,
To work out a life of our own.

All of them were thrown away,
Yet when we meet again today,
The crowd disappears and we're alone.
I long to put my arms around you now!
But it wouldn't be the same, somehow.

REPEAT REFRAIN

Let's Do It, Let's Fall in Love

VERSE
When the little bluebird,
Who has never said a word,
Starts to sing "Spring, spring,"
When the little bluebell,
In the bottom of the dell,
Starts to ring "Ding, ding,"
When the little blue clerk,
In the middle of his work,
Starts a tune to the moon up above,
It is nature, that's all,
Simply telling us to fall
In love.

REFRAIN I
And that's why Chinks do it, Japs do it,
Up in Lapland, little Lapps do it,
Let's do it, let's fall in love.
In Spain, the best upper sets do it,

Lithuanians and Letts do it,
Let's do it, let's fall in love.
The Dutch in old Amsterdam do it,
Not to mention the Finns,
Folks in Siam do it,
Think of Siamese twins.
Some Argentines, without means, do it,
People say, in Boston, even beans do it,
Let's do it, let's fall in love.

REFRAIN 2
The nightingales, in the dark, do it,
Larks, k-razy for a lark, do it,
Let's do it, let's fall in love.
Canaries, caged in the house, do it,
When they're out of season, grouse do it,
Let's do it, let's fall in love.
The most sedate barnyard fowls do it,
When a chanticleer cries,
High-browed old owls do it,
They're supposed to be wise,
Penguins in flocks, on the rocks, do it,
Even little cuckoos, in their clocks, do it,
Let's do it, let's fall in love.

REFRAIN 3
Romantic sponges, they say, do it,
Oysters, down in Oyster Bay, do it,
Let's do it, let's fall in love.
Cold Cape Cod clams, 'gainst their wish, do it,
Even lazy jellyfish do it,

Let's do it, let's fall in love.
Electric eels, I might add, do it,
Though it shocks 'em, I know.
Why ask if shad do it?
Waiter, bring me shad roe.
In shallow shoals, English soles do it,
Goldfish, in the privacy of bowls, do it,
Let's do it, let's fall in love.

REFRAIN 3 (ENGLISH PRODUCTION)
Young whelks and winkles, in pubs, do it,
Little sponges, in their tubs, do it.
Let's do it, let's fall in love.
Cold salmon, quite 'gainst their wish, do it,
Even lazy jellyfish do it,
Let's do it, let's fall in love.
The most select schools of cod do it,
Though it shocks 'em, I fear,
Sturgeon, thank God, do it,
Have some caviar, dear.
In shady shoals, English soles do it,
Goldfish, in the privacy of bowls, do it,
Let's do it, let's fall in love.

REFRAIN 4
The dragonflies, in the reeds, do it,
Sentimental centipedes do it,
Let's do it, let's fall in love.
Mosquitoes, heaven forbid, do it,
So does ev'ry katydid, do it,
Let's do it, let's fall in love.

The most refined lady bugs do it,
When a gentleman calls,
Moths in your rugs, do it,
What's the use of moth balls?
Locusts in trees do it, bees do it,
Even overeducated fleas do it,
Let's do it, let's fall in love.

REFRAIN 5
The chimpanzees, in the zoos, do it,
Some courageous kangaroos do it,
Let's do it, let's fall in love.
I'm sure giraffes, on the sly, do it,
Heavy hippopotami do it,
Let's do it, let's fall in love.
Old sloths who hang down from twigs do it,
Though the effort is great,
Sweet guinea pigs do it,
Buy a couple and wait.
The world admits bears in pits do it,
Even pekineses in the Ritz, do it,
Let's do it, let's fall in love.

Which?

Which is the right life,
The simple or the night life?
When, pray, should one rise,
At sunset or at sunrise?

Which should be upper,
My breakfast or my supper?
Which is the right life,
Which?
If the wood nymph left the park,
Would Park Avenue excite her?
Would the glowworm trade her spark
For the latest Dunhill lighter?
Here's a question I would pose,
Tell me which the sweeter smell makes,
The aroma of the rose
Or the perfume that Chanel makes?
Which land is dreamier,
Arcadia or Bohemia?
Who'll tell the answer,
The daisy or the dancer?
Which life is for me,
The peaceful or the stormy?
Which is the right man,
Walt Whitman or Paul Whiteman,
Which?
Should I read Euripides or continue with the *Graphic*?
Hear the murmur of the breeze or the roaring of the
 traffic?
Should I make one man my choice
And regard divorce as treason,
Or should I, like Peggy Joyce,
Get a new one ev'ry season?
Which is the right life,
The simple or the night life?
When, pray, should one rise,
At sunset or at sunrise?

Which should be the upper,
My breakfast or my supper?
Which is the right life,
Which!

Wake Up and Dream

VERSE I
When you grumble and sigh,
And you ask yourself why
You've the weight of the world on your mind,
Did you ever reflect
It's because you neglect
The dreams that you've left behind?
They were gay, they were mad,
Those dreams you had,
And you welcomed them all with open arms.
But in giving your life
To the world and his wife,
You have fallen asleep to their charms.

REFRAIN
Wake up and dream,
It's so easy to dream,
Things are really not what they seem.
Wake up and dream.
Open your eyes,
Take a look at the skies,
Where the stars so romantic'lly gleam.
Wake up and dream.
Ev'ry moment you're bored is a sword

Of hari-kari in you.
If you wake up, you'll find you've the mind
Of Master Barrie in you.
Listen, young man,
You were once Peter Pan
And you've simply forgotten your theme,
Wake up and dream.

When you're conscious that you've
Simply got in a groove,
And you've lost all desire for a spree,
If you wake up and dream,
Life will suddenly seem
As gay as it used to be.
And though any amount
Of men who count
Will maintain that you've quite gone off your head,
Never mind what they say,
Let your dreams dream away,
And you'll still be alive when they're dead.

REPEAT REFRAIN

Looking at You

VERSE
I've gone afar,
Collecting objets d'art,
I know the whole game by heart.

Why, Joe Duveen
Will tell you what I mean,
'Twas I who gave him his start.
But since I looked, dear, in your direction,
I've quite forgotten my art collection.
To be exact,
You simply prove the fact
That nature's greater than art.

Looking at you,
While troubles are fleeing.
I'm admiring the view,
'Cause it's you I'm seeing.
And the sweet honeydew
Of well-being settles upon me.
What is this light
That shines when you enter?
Like a star in the night,
And what's to prevent 'er
From destroying my sight,
If you center all of it on me?
Looking at you,
I'm filled with the essence of
The quintessence of
Joy.
Looking at you,
I hear poets tellin' of
Lovely Helen of
Troy, darling.
Life seemed so gray
I wanted to end it,

Till that wonderful day
You started to mend it.
And if you'll only stay,
Then I'll spend it looking at you.

What Is This Thing Called Love?

VERSE I
I was a humdrum person,
Leading a life apart,
When love flew in through my window wide
And quickened my humdrum heart.
Love flew in through my window,
I was so happy then.
But after love had stayed a little while,
Love flew out again.

REFRAIN
What is this thing called love?
This funny thing called love?
Just who can solve its mystery?
Why should it make a fool of me?
I saw you there one wonderful day.
You took my heart and threw it away.
That's why I ask the Lord in heaven above,
What is this thing called love?

VERSE 2
You gave me days of sunshine,
You gave me nights of cheer,

You made my life an enchanted dream
Till somebody else came near.
Somebody else came near you,
I felt the winter's chill
And now I sit and wonder night and day
Why I love you still.

REPEAT REFRAIN

I'm a Gigolo

VERSE
I should like you all to know,
I'm a famous gigolo.
And of lavender, my nature's got just a dash in it.
As I'm slightly undersexed,
You will always find me next
To some dowager who's wealthy rather than passionate.
Go to one of those night club places
And you'll find me stretching my braces
Pushing ladies with lifted faces 'round the floor.
But I must confess to you
There are moments when I'm blue.
And I ask myself whatever I do it for.

REFRAIN
I'm a flower that blooms in the winter,
Sinking deeper and deeper in "snow."
I'm a baby who has
No mother but jazz,

I'm a gigolo.
Ev'ry morning, when labor is over,
To my sweet-scented lodgings I go,
Take the glass from the shelf
And look at myself,
I'm a gigolo.
I get stocks and bonds
From faded blondes
Ev'ry twenty-fifth of December.
Still I'm just a pet
That men forget
And only tailors remember.
Yet when I see the way all the ladies
Treat their husbands who put up the dough,
You cannot think me odd
If then I thank God
I'm a gigolo.

You Do Something to Me

VERSE I
I was mighty blue,
Thought my life was through,
Till the heavens opened,
And I gazed at you.
Won't you tell me, dear,
Why, when you appear,
Something happens to me
And the strangest feeling goes through me?

You do something to me,
Something that simply mystifies me.
Tell me, why should it be
You have the pow'r to hypnotize me?
Let me live 'neath your spell,
Do do that voodoo that you do so well,
For you do something to me
That nobody else could do.

VERSE 2
If I seem to stray
When you talk this way
It's because I'm wondering
What I ought to say.
I could cry, please don't,
But I believe I won't,
For when you talk to me
Such a soothing feeling goes through me.

REPEAT REFRAIN

You've Got That Thing

VERSE
Since first you blew in like a boisterous breeze
I often have wondered, dear,
Why gentlemen all seem to fall on their knees
The moment that you appear?
Your fetching physique is hardly unique,

You're mentally not so hot;
You'll never win laurels because of your morals,
But I'll tell you what you've got

REFRAIN I
You've got that thing, you've got that thing,
That thing that makes birds forget to sing.
Yes, you've got that thing, that certain thing.
You've got that charm, that subtle charm
That makes young farmers desert the farm,
'Cause you've got that thing, that certain thing.
You've got what Adam craved when he
With love for Eve was tortured,
She only had an apple tree,
But you, you've got an orchard.
You've got those ways, those taking ways
That make me rush off to Cartier's
For a wedding ring,
You've got that thing.

REFRAIN 2
You've got that thing, you've got that thing,
That thing that makes vines prefer to cling.
Yes, you've got that thing, that certain thing.
You've got those looks, those fatal looks.
That make book censors enjoy their books,
'Cause you've got that thing, that certain thing.
Just what made Samson be, for years,
Delilah's lord and keeper?
She only had a pair of shears.
But you, you've got a reaper.
You've got that pow'r, that pow'r to grip

That makes me map out a wedding trip
For the early spring,
You've got that thing.

REFRAIN 3
You've got that thing, you've got that thing,
That thing that makes bees refuse to sting.
Yes, you've got that thing, that certain thing.
You've got that kiss, that kiss that warms,
That makes reformers reform reforms,
'Cause you got that thing, that certain thing.
They tell us Trojan Helen's lips
Made ev'ry man her slavey.
If her face launched a thousand ships
Well, yours could launch a navy.
You've got that love, and such a lot*
It makes me think you're prepared for what
Any stork might bring.
You've got that thing.

*Or (last 4 lines): You've ideas inside your head
That make me order an extra bed
With an extra spring.
You've got that thing.

The Tale of the Oyster

Down by the sea lived a lonesome oyster,
Ev'ry day getting sadder and moister.
He found his home life awf'lly wet,
And longed to travel with the upper set.

Poor little oyster.
Fate was kind to that oyster we know,
When one day the chef from the Park Casino
Saw that oyster lying there,
And said, "I'll put you on my bill of fare."
Lucky little oyster.
See him on his silver platter,
Watching the queens of fashion chatter.
Hearing the wives of millionaires
Discuss their marriages and their love affairs.
Thrilled little oyster.
See that bivalve social climber
Feeding the rich Mrs. Hoggenheimer,
Think of his joy as he gaily glides
Down to the middle of her gilded insides.
Proud little oyster.
After lunch Mrs. H. complains,
And says to her hostess, "I've got such pains.
I came to town on my yacht today,
But I think I'd better hurry back to Oyster Bay."
Scared little oyster.
Off they go thru the troubled tide,
The yacht rolling madly from side to side.
They're tossed about till that poor young oyster
Finds that it's time he should quit his cloister.
Up comes the oyster.
Back once more where he started from.
He murmured, "I haven't a single qualm,
For I've had a taste of society
And society has had a taste of me."
Wise little oyster.

You Don't Know Paree

VERSE

You come to Paris, you come to play;
You have a wonderful time, you go away.
And, from then on, you talk of Paris knowingly;
You may know Paris, you don't know Paree.

REFRAIN

Though you've been around a lot,
And danced a lot, and laughed a lot,
You don't know Paree.
You may say you've seen a lot,
And heard a lot, and learned a lot;
You don't know Paree.
Paree will still be laughing after
Ev'ry one of us disappears,
But never once forget her laughter
Is the laughter that hides the tears.
And until you've lived a lot,
And loved a lot, and lost a lot,
You don't know Paree,
You don't know Paree.

I'm Unlucky at Gambling

VERSE 1

I went to Monte Carlo the other day,
I went to Monte Carlo to have some play;
I went to Monte Carlo and, straightaway

I went and fell in love with a croupier.
The croupier advised me to back the red,
The croupier was handsome, I lost my head;
And when the game was over and love was dead,
I realized I'd played on the black instead.

REFRAIN

For I'm unlucky at gambling,
And I'm unlucky in love.
Why should I go on scrambling
To get to heaven above?
It's bad enough to lose your purse
But when you lose your heart, it's even worse.
Oh, I'm unlucky at gambling
And I'm unlucky in love.

VERSE 2

I took the croupier to a picture show,
I took the croupier to a picture show,
And though I snuggled close when the lights were low,
The croupier impressed me as rather slow.
I said I like John Gilbert a lot, don't you?
I said I like John Gilbert a lot, don't you?
He didn't answer but when the show was through
I realized that he liked John Gilbert too.

REPEAT REFRAIN

I Worship You

Back in the days when Greece was mighty,
Men used to worship Aphrodite.
When the Phoenicians threw a party,
The driest host drank a toast to Astarte.
The big Egyptian sacrifices
Were made to please the goddess Isis,
And one of my most ancient vices
Is my worship of you.

REFRAIN
I don't love you, dear,
I swear it's true,
I don't love you, dear,
I worship you.
Must I modify
My point of view?
Why should I be odd if I
Worship you?
On that sacred day
When you become mine,
Somewhere far away
I'll build you a shrine.
There I'll put you, dear,
And when I do,
I'll get on my knees
And worship you.

The Queen of Terre Haute

VERSE

My mother and father
Once went to a lot of bother
To make me the happiest of girls.
To better my station
They gave me an education,
Not to mention a string of pearls.
But in spite of my backing,
I still feel there's something lacking,
And that fate has rather let me down,
For instead of being famous
I'm an unknown ignoramus
From a small Middle Western town.

REFRAIN

Why couldn't I have been Salome,
Or Mary Pickford,
Or Joan of Arc?
If I were El'nor Glyn,
Or even Anne Boleyn,
The future wouldn't look half so dark.
Why couldn't I be Whistler's Mother?
Or any other woman of note?
Why did the gods decree
That I should only be
The Queen of Terre Haute?

Why Don't We Try Staying Home?

VERSE 1

Since first we started out, we've simply run about,
And life's been one long rout unending.
We're always op'ning plays,
Or closing cabarets,
It seems to me our ways need mending.
Let's let the dressy dames with hyphenated names
In search of faster games fly by.
Content with being slow,
We'll never let them know
The nicest place to go is bye-bye.

REFRAIN 1

Why don't we try staying home?
Why don't we try not to roam?
What if we threw a party or two,
And asked only you and me?
I long to sit by the fireside,
My girl, with me sitting by 'er side,
Wouldn't that be nice?
We've tried ev'ry thing else twice,
So why don't we try staying home?

VERSE 2

Let us begin to cut the folks who merely strut
And talk of nothing but their incomes.
Let's have no further use
For going on the loose
The moment orange juice and gin comes.

Our little love affair will make us cease to care
How many parties they're giving.
We're done with being smart,
And so we're goin' to start
To learn the gentle art of living.

REFRAIN 2
Why don't we try staying home?
Why don't we try not to roam?
What if we threw a party or two,
And asked only you and me?
Though all the home folks that we know
Pay for it later in Reno,
Just being still
Might give us a brand-new thrill,
So why don't we try staying home?

Love For Sale

VERSE
When the only sound in the empty street
Is the heavy tread of the heavy feet
That belong to a lonesome cop,
I open shop.
When the moon so long has been gazing down
On the wayward ways of this wayward town
That her smile becomes a smirk,
I go to work.

Love for sale,
Appetizing young love for sale.
Love that's fresh and still unspoiled,
Love that's only slightly soiled,
Love for sale.
Who will buy?
Who would like to sample my supply?
Who's prepared to pay the price
For a trip to paradise?
Love for sale.
Let the poets pipe of love
In their childish way,
I know ev'ry type of love
Better far than they.
If you want the thrill of love,
I've been thru the mill of love,
Old love, new love,
Ev'ry love but true love.
Love for sale,
Appetizing young love for sale.
If you want to buy my wares
Follow me and climb the stairs,
Love for sale.

I Happen to Like New York

I happen to like New York.
I happen to like this town.
I like the city air, I like to drink of it,
The more I know New York, the more I think of it.
I like the sight and the sound and even the stink of it.
I happen to like New York.
I like to go to Battery Park
And watch those liners booming in.
I often ask myself, why should it be
That they should come so far
From across the sea?
I suppose it's because they all agree with me,
They happen to like New York.
Last Sunday afternoon
I took a trip to Hackensack
But after I gave Hackensack the once-over
I took the next train back.
I happen to like New York.
I happen to like this burg.
And when I have to give the world
A last farewell
And the undertaker
Starts to ring my funeral bell,
I don't want to go to heaven,
Don't want to go to hell.
I happen to like New York.
I happen to like New York.

After You, Who?

VERSE

Though with joy I should be reeling
That at last you came my way,
There's no further use concealing
That I'm feeling far from gay.
For the rare allure about you
Makes me all the plainer see
How inane, how vain, how empty
Life without you would be.

REFRAIN

After you, who
Could supply my sky of blue?
After you, who
Could I love?
After you, why
Should I take the time to try,
For who else could qualify
After you, who?
Hold my hand and swear
You'll never cease to care,
For without you there what could I do?
I could search years
But who else could change my tears
Into laughter after you?

Night and Day

Like the beat beat beat of the tom-tom
When the jungle shadows fall,
Like the tick tick tock of the stately clock
As it stands against the wall,
Like the drip drip drip of the raindrops
When the sum'r show'r is through,
So a voice within me keeps repeating
You—You—You.

REFRAIN
Night and day you are the one,
Only you beneath the moon and under the sun,
Whether near to me or far
It's no matter, darling, where you are,
I think of you, night and day.
Day and night, why is it so
That this longing for you follows wherever I go?
In the roaring traffic's boom,
In the silence of my lonely room,
I think of you, night and day.
Night and day under the hide of me
There's an, oh, such a hungry yearning burning inside
 of me,
And its torment won't be through
Till you let me spend my life making love to you
Day and night, night and day.

I've Got You on My Mind

VERSE

SHE: You can't be much surprised to hear
 I think you're sweller than swell,

HE: But granting all your virtues, dear,
 You've certain failings as well.

SHE: You don't sing enough, you don't dance enough,

HE: You don't drink the great wines of France
 enough!

SHE: You're not wild enough,

HE: You're not gay enough,

SHE: You don't let me lead you astray enough.

HE: You don't live enough, you don't dare enough,
 You don't give enough,

SHE: You don't care enough,

HE: You don't make my sad life sunny enough.

SHE: Yet, sweetheart, funny enough—

REFRAIN

SHE: I've got you on my mind
 Although I'm disinclined,
 You're not so hot, you,
 But I've got you on my mind.

HE: I'd thank the gods above
 If I could only love
 Somebody not you
 But I've got you on my mind.

SHE: Let my poor upset leisure be
 Otherwise my pet treasure be

HE: And arrange to let pleasure be
 A bit less refined.

BOTH: For, darling, not until
 I get that famous thrill
 Will I be resigned.
 I've got you on my mind.

Mister and Missus Fitch

VERSE

On a farm far from pleasant,
No pair was more peasant
Than Mister and Missus Fitch.
Their days, each one duller,
Were so lacking in color
They didn't know which was which.
When suddenly tilling the soil
Mister Fitch struck oil.

REFRAIN

Mister and Missus Fitch one day
Hit town, determined to play.
Mister and Missus Fitch were green,
Ambitious, but rich.
And soon the crowd they call "elite"
Were fighting madly to meet
The young, attractive, and rich,
Mister and Missus Fitch.
When they called for champagne,
Champagne arrived.
An aeroplane,

The plane arrived.
A private train,
The train arrived.
But when they called for cash
The Crash arrived.
Now men who once knew Missus Fitch
Refer to her as a bitch.
While the girls who once loved Mister Fitch
Say he always was a son of a bitch.
So love and kisses,
Mister and Missus Fitch.

The Physician

VERSE

Once I loved such a shattering physician,
Quite the best-looking doctor in the state.
He looked after my physical condition,
And his bedside manner was great.
When I'd gaze up and see him there above me,
Looking less like a doctor than a Turk,
I was tempted to whisper, "Do you love me,
Or do you merely love your work?"

REFRAIN I

He said my bronchial tubes were entrancing,
My epiglottis filled him with glee,
He simply loved my larynx
And went wild about my pharynx,

But he never said he loved me.
He said my epidermis was darling,
And found my blood as blue as could be,
He went through wild ecstatics,
When I showed him my lymphatics,
But he never said he loved me.
And though, no doubt,
It was not very smart of me,
I kept on a-wracking my soul
To figure out
Why he loved ev'ry part of me,
And yet not me as a whole.
With my esophagus he was ravished,
Enthusiastic to a degree,
He said 'twas just enormous,
My appendix vermiformis,
But he never said he loved me.

REFRAIN 2
He said my cerebellum was brilliant,
And my cerebrum far from N.G.,
I know he thought a lotta
My medulla oblongata,
But he never said he loved me.
He said my maxillaries were marvels,
And found my sternum stunning to see,
He did a double hurdle
When I shook my pelvic girdle,
But he never said he loved me.
He seemed amused
When he first made a test of me

To further his medical art,
Yet he refused
When he'd fix up the rest of me,
To cure that ache in my heart.
I know he thought my pancreas perfect,
And for my spleen was keen as could be,
He said of all his sweeties,
I'd the sweetest diabetes,
But he never said he loved me.

REFRAIN 3
He said my vertebrae were "sehr schöne,"
And called my coccyx "plus que gentil,"
He murmured "molto bella,"
When I sat on his patella,
But he never said he loved me.
He took a fleeting look at my thorax,
And started singing slightly off key,
He cried, "May Heaven strike us,"
When I played my umbilicus,
But he never said he loved me.
As it was dark,
I suggested we walk about
Before he returned to his post.
Once in the park,
I induced him to talk about
The thing I wanted the most.
He lingered on with me until morning,
Yet when I tried to pay him his fee,
He said, "Why, don't be funny,
It is I who owe you money,"
But he never said he loved me.

Miss Otis Regrets

Miss Otis regrets she's unable to lunch today,
Madam,
Miss Otis regrets she's unable to lunch today.
She is sorry to be delayed,
But last evening down in lovers' lane she strayed,
Madam,
Miss Otis regrets she's unable to lunch today.
When she woke up and found
That her dream of love was gone,
Madam,
She ran to the man
Who had led her so far astray,
And from under her velvet gown
She drew a gun and shot her lover down,
Madam,
Miss Otis regrets she's unable to lunch today.
When the mob came and got her
And dragged her from the jail,
Madam,
They strung her upon
The old willow across the way,
And the moment before she died
She lifted up her lovely head and cried,
Madam,
"Miss Otis regrets she's unable to lunch today."

I Get a Kick Out of You

VERSE

My story is much too sad to be told,
But practically ev'rything leaves me totally cold.
The only exception I know is the case
Where I'm out on a quiet spree
Fighting vainly the old ennui
And I suddenly turn and see
Your fabulous face.

REFRAIN

I get no kick from champagne.
Mere alcohol doesn't thrill me at all,
So tell me why should it be true
That I get a kick out of you?
Some get a kick from cocaine.
I'm sure that if I took even one sniff
That would bore me terrific'ly too
Yet I get a kick out of you.
I get a kick ev'ry time I see
You're standing there before me.
I get a kick though it's clear to me
You obviously don't adore me.
I get no kick in a plane.
Flying too high with some guy in the sky
Is my idea of nothing to do,
Yet I get a kick out of you.

All Through the Night

VERSE

The day is my enemy,
The night my friend,
For I'm always so alone
Till the day draws to an end.
But when the sun goes down
And the moon comes through,
To the monotone of the evening's drone
I'm all alone with you.

REFRAIN

All through the night I delight in your love.
All through the night you're so close to me.
All through the night from a height far above,
You and your love bring me ecstasy.
When dawn comes to waken me,
You're never there at all.
I know you've forsaken me
Till the shadows fall,
But then once again I can dream I've the right
To be close to you all through the night.

If I stopped to think twice
I know I'd hurry away,
But it all is so nice
So I'll only think once and stay.
All through the night I delight in your love.
All through the night, oh so close to me.
All through the night, under bright stars above

You and your love will bring ecstasy.
When dawn's overtaken us, we'll sadly say goodbye,
Till dreams reawaken us and the moon is high.
And then, once again, will I know I was right
Staying close to you, all through the night.

You're the Top

VERSE I

At words poetic, I'm so pathetic
That I always have found it best,
Instead of getting 'em off my chest,
To let 'em rest unexpressed.
I hate parading
My serenading,
As I'll probably miss a bar,
But if this ditty
Is not so pretty,
At least it'll tell you
How great you are.

REFRAIN I

You're the top!
You're the Colosseum.
You're the top!
You're the Louvre Museum.
You're a melody from a symphony by Strauss,
You're a Bendel bonnet,
A Shakespeare sonnet,

You're Mickey Mouse.
You're the Nile,
You're the Tow'r of Pisa,
You're the smile
On the Mona Lisa.
I'm a worthless check, a total wreck, a flop,
But if, baby, I'm the bottom
You're the top!

VERSE 2
Your words poetic are not pathetic.
On the other hand, boy, you shine,
And I can feel after every line
A thrill divine
Down my spine.
Now gifted humans like Vincent Youmans
Might think that your song is bad,
But for a person who's just rehearsin'
Well, I gotta say this my lad:

REFRAIN 2
You're the top!
You're Mahatma Gandhi.
You're the top!
You're Napoleon brandy.
You're the purple light of a summer night in Spain,
You're the National Gall'ry,
You're Garbo's sal'ry,
You're cellophane.
You're sublime,
You're a turkey dinner,

You're the time
Of the Derby winner.
I'm a toy balloon that is fated soon to pop,
But if, baby, I'm the bottom
You're the top!

REFRAIN 3
You're the top!
You're a Ritz hot toddy.
You're the top!
You're a Brewster body.
You're the boats that glide on the sleepy Zuider Zee,
You're a Nathan panning,
You're Bishop Manning,
You're broccoli.
You're a prize,
You're a night at Coney,
You're the eyes
Of Irene Bordoni.
I'm a broken doll, a fol-de-rol, a blop,
But if, baby, I'm the bottom
You're the top!

REFRAIN 4
You're the top!
You're an Arrow collar.
You're the top!
You're a Coolidge dollar.
You're the nimble tread of the feet of Fred Astaire,
You're an O'Neill drama,
You're Whistler's mama,

You're Camembert.
You're a rose,
You're Inferno's Dante,
You're the nose
On the great Durante.
I'm just in the way, as the French would say
"De trop,"
But if, baby, I'm the bottom
You're the top.

REFRAIN 5
You're the top!
You're a Waldorf salad.
You're the top!
You're a Berlin ballad.
You're a baby grand of a lady and a gent,
You're an old Dutch master,
You're Mrs. Astor,
You're Pepsodent.
You're romance,
You're the steppes of Russia,
You're the pants on a Roxy usher.
I'm a lazy lout that's just about to stop,
But if, baby, I'm the bottom
You're the top.

REFRAIN 6
You're the top!
You're a dance in Bali.
You're the top!
You're a hot tamale.

You're an angel, you, simply too, too, too diveen,
You're a Botticelli,
You're Keats,
You're Shelley,
You're Ovaltine.
You're a boon,
You're the dam at Boulder,
You're the moon over Mae West's shoulder.
I'm a nominee of the G.O.P.
 or GOP,
But if, baby, I'm the bottom
You're the top.

REFRAIN 7
You're the top!
You're the Tower of Babel.
You're the top!
You're the Whitney Stable.
By the river Rhine,
You're a sturdy stein of beer,
You're a dress from Saks's,
You're next year's taxes,
You're stratosphere.
You're my thoist,
You're a Drumstick Lipstick,
You're da foist
In da Irish Svipstick.
I'm a frightened frog
That can find no log
To hop,
But if, baby, I'm the bottom
You're the top!

RENO: You're the top!
You're my Swanee River.
You're the top!
You're a goose's liver.
You're the boy who dares
Challenge Mrs. Baer's son, Max.
You're a Russian ballet,
You're Rudy Vallee,

MOON: You're Phenolax!!!!

RENO: You're much more,
You're a field of clover—

BILLY: I'm the floor
When the ball is over. . . .

Parody version by Irving Berlin

You're the top!
You're Miss Pinkham's tonic.
You're the top!
You're a high colonic.
You're the burning heat of a bridal suite in use,
You're the breasts of Venus,
You're King Kong's penis,
You're self-abuse.
You're an arch
In the Rome collection.
You're the starch
In a groom's erection.
I'm a eunuch who
Has just been through an op,
But if, Baby, I'm the bottom
You're the top.

Anything Goes

VERSE

Times have changed
And we've often rewound the clock
Since the Puritans got a shock
When they landed on Plymouth Rock.
If today
Any shock they should try to stem,
'Stead of landing on Plymouth Rock,
Plymouth Rock would land on them.

REFRAIN I

In olden days, a glimpse of stocking
Was looked on as something shocking,
But now, God knows,
Anything goes.
Good authors too who once knew better words
Now only use four-letter words
Writing prose,
Anything goes.
If driving fast cars you like,
If low bars you like,
If old hymns you like,
If bare limbs you like,
If Mae West you like,
Or me undressed you like,
Why, nobody will oppose.
When ev'ry night, the set that's smart is in-
Truding in nudist parties in
Studios,
Anything goes.

When Missus Ned McLean (God bless her)
Can get Russian reds to "yes" her,
Then I suppose
Anything goes.
When Rockefeller still can hoard en-
Ough money to let Max Gordon
Produce his shows,
Anything goes.
The world has gone mad today
And good's bad today,
And black's white today,
And day's night today,
And that gent today
You gave a cent today
Once had several châteaux.
When folks who still can ride in jitneys
Find out Vanderbilts and Whitneys
Lack baby clo'es,
Anything goes.

If Sam Goldwyn can with great conviction
Instruct Anna Sten in diction,
Then Anna shows
Anything goes.
When you hear that Lady Mendl standing up
Now turns a handspring landing up-
On her toes,
Anything goes.
Just think of those shocks you've got

And those knocks you've got
And those blues you've got
From that news you've got
And those pains you've got
(If any brains you've got)
From those little radios.
So Missus R., with all her trimmin's,
Can broadcast a bed from Simmons
'Cause Franklin knows
Anything goes.

Earlier version of first refrain
In former times a glimpse of stocking
Was looked on as something shocking,
But now God knows—
Anything goes.
Novelists who once knew better words
Now only use four letter words for their prose—
Anything Goes.
If saying your pr'yers you like,
If green pears you like,
If old chairs you like,
If backstairs you like,
If love affairs you like
With young bears you like,
Why, nobody will oppose.
And every night the set that's smart is
Indulging in nudist parties in studios,
Anything Goes.

Revised Version

In olden days, a glimpse of stocking
Was looked on as something shocking,
But now, God knows,
Anything goes.
Good authors too who once knew better words
Now only use four-letter words
Writing prose,
Anything goes.
The world has gone mad today
And good's bad today.
And black's white today,
And day's night today,
When most guys today
That women prize today
Are just silly gigolos.
So though I'm not a great romancer
I know that you're/I'm bound to answer
When I/you propose
Anything goes.

REFRAIN 2
When mothers pack and leave poor father
Because they decide they'd rather
Be tennis pros,
Anything goes.
When Missus Ned McLean, God bless her,
Can get Russian Reds to "yes" her,
Then I suppose
Anything goes.

If driving fast cars you like,
If old hymns you like,
Or bare limbs you like,
If Mae West you like,
Or me undressed you like,
Why nobody would oppose.
When ev'ry night the set that's smart is
Indulging in nudist parties
In studios,
Anything goes.

REFRAIN 3
When you hear that Lady Mendl, standing up,
Now does a handspring landing up
On her toes,
Anything goes.
When Sam Goldwyn can with great conviction
Instruct Anna Sten in diction,
Then Anna shows
Anything goes.
Just think of those shocks you got
And those knocks you got
And those blues you got
From that news you got,
And those pains you got
(If any brains you got)
From those little radios.
So Missus R with all her trimmins
Can broadcast a bed for Simmons
'Cause Franklin knows
Anything goes.

Blow, Gabriel, Blow

VERSE
[TRUMPET CALL]

RENO: Do you hear that playin'?

CHORUS: Yes, I hear that playin'.

RENO: Do you know who's playin'?

CHORUS: No, who is that playin'?

RENO &
CHORUS: Why, it's Gabriel, Gabriel playin',
 Gabriel, Gabriel sayin',

RENO: "Will you be ready to go when I blow my
 horn?"

REFRAIN

Oh, blow, Gabriel, blow
Go on and blow, Gabriel, blow!
I've been a sinner, I've been a scamp,
But now I'm willin' to trim my lamp,
So blow, Gabriel, blow!
I was low, Gabriel, low,
Mighty low, Gabriel, low.
But now since I have seen the light,
I'm good by day and I'm good by night,
So blow, Gabriel, blow.
Once I was headed for hell,
Yes, once I was headed for hell;
But when I got to Satan's door
I heard you blowin' on your horn once more,
So I said, "Satan, farewell!"
And now I'm all ready to fly,

Yes, to fly higher and higher!
'Cause I've gone through brimstone and I've been
 through the fire,
And I've purged my soul and my heart too,
So climb up the mountaintop and start to
Blow, Gabriel, blow.
Go on and blow, Gabriel, blow!
I want to join your happy band
And play all day in the Promised Land,
So blow, Gabriel, blow!

Thank You So Much, Mrs. Lowsborough-Goodby

Mrs. Lowsborough-Goodby gives weekends
And her weekends are not a success,
But she asks you so often
You finally soften
And end by answering "Yes."
When I left Mrs. Lowsborough-Goodby's
The letter I wrote was polite
But it would have been bliss
Had I dared write her this,
The letter I wanted to write:

Thank you so much, Mrs. Lowsborough-Goodby,
Thank you so much.

Thank you so much for that infinite weekend with you.
Thank you a lot, Mrs. Lowsborough-Goodby,
Thank you a lot,
And don't be surprised if you suddenly should be quietly
 shot
For the clinging perfume
And that damp little room,
For those cocktails so hot
And the bath that was not,
For those guests so amusing and mentally bracing
Who talked about racing and racing and racing,
For the ptomaine I got from your famous tin salmon,
For the fortune I lost when you taught me backgammon,
For those mornings I spent with your dear but deaf
 mother,
For those evenings I passed with that bounder, your
 brother,
And for making me swear to myself there and then
Never to go for a weekend again.
Thank you so much, Mrs. Lowsborough-Goodby,
Thank you, thank you so much.

Don't Fence Me In

VERSE I
Wild Cat Kelly, looking mighty pale,
Was standing by the sheriff's side,
And when that sheriff said, "I'm sending you to jail,"
Wild Cat raised his head and cried:

Oh, give me land, lots of land under starry skies above,
Don't fence me in.
Let me ride thru the wide-open country that I love,
Don't fence me in.
Let me be by myself in the evening breeze,
Listen to the murmur of the cottonwood trees,
Send me off forever, but I ask you, please,
Don't fence me in.
Just turn me loose,
Let me straddle my old saddle underneath the Western
skies.
On my cayuse,
Let me wander over yonder till I see the mountains rise.
I want to ride to the ridge where the West commences,
Gaze at the moon till I lose my senses,
Can't look at hobbles and I can't stand fences,
Don't fence me in.

VERSE 2

Wild Cat Kelly, back again in town,
Was sitting by his sweetheart's side,
And when his sweetheart said, "Come on, let's settle
down,"
Wild Cat raised his head and cried:

REPEAT REFRAIN

Begin the Beguine

When they begin the beguine
It brings back the sound of music so tender,
It brings back a night of tropical splendor,
It brings back a memory ever green.
I'm with you once more under the stars
And down by the shore an orchestra's playing,
And even the palms seem to be swaying
When they begin the beguine.
To live it again is past all endeavor
Except when that tune clutches my heart.
And there we are, swearing to love forever,
And promising never,
Never to part.
What moments divine, what rapture serene,
Till clouds came along to disperse the joys we had
 tasted,
And now when I hear people curse the chance that was
 wasted,
I know but too well what they mean.
So don't let them begin the beguine!
Let the love that was once a fire remain an ember.
Let it sleep like the dead desire I only remember
When they begin the beguine.
Oh yes, let them begin the beguine, make them play!
Till the stars that were there before return above you,
Till you whisper to me once more, "Darling, I love
 you!"
And we suddenly know what heaven we're in
When they begin the beguine.

Just One of Those Things

VERSE

As Dorothy Parker once said to her boy friend,
"Fare thee well,"
As Columbus announced when he knew he was bounced,
"It was swell, Isabelle, swell,"
As Abélard said to Héloïse,
"Don't forget to drop a line to me, please,"
As Juliet cried in her Romeo's ear,
"Romeo, why not face the fact, my dear?"

REFRAIN

It was just one of those things,
Just one of those crazy flings,
One of those bells that now and then rings,
Just one of those things.
It was just one of those nights,
Just one of those fabulous flights,
A trip to the moon on gossamer wings,
Just one of those things.
If we'd thought a bit
Of the end of it,
When we started painting the town,
We'd have been aware
That our love affair
Was too hot not to cool down.
So goodbye, dear, and amen.
Here's hoping we meet now and then,
It was great fun,
But it was just one of those things.

Easy To Love

VERSE
I know too well that I'm
Just wasting precious time
In thinking such a thing could be
That you could ever care for me.
I'm sure you hate to hear
That I adore you, dear,
But grant me, just the same,
I'm not entirely to blame, For

REFRAIN 1
You'd be so easy to love,
So easy to idolize, all others above,
So sweet to waken with,
So nice to sit down to eggs and bacon with.
We'd be so grand at the game,
So carefree together that it does seem a shame
That you can't see
Your future with me,
'Cause you'd be, oh, so easy to love.

REFRAIN 2
You'd be so easy to love,
So easy to idolize, all others above,
So worth the yearning for,
So swell to keep ev'ry home fire burning for.
Oh, how we'd bloom, how we'd thrive
In a cottage for two, or even three, four, or five,
So try to see

Your future with me,
'Cause they'd be, oh, so easy to love.

REFRAIN 3
You'd be so easy to love,
So easy to worship as an angel above,
Just made to pray before,
Just right to stay home and walk the baby for.
I know I once left you cold,
But call me your "lamb" and take me back to the fold.
If you'll agree,
Why, I guarantee
That I'll be, oh, so easy to love.

I've Got You Under My Skin

REFRAIN
I've got you under my skin,
I've got you deep in the heart of me,
So deep in my heart, you're really a part of me,
I've got you under my skin.

I tried so not to give in,
I said to myself, "This affair never will go so well."
But why should I try to resist when, darling, I know so
 well
I've got you under my skin.

I'd sacrifice anything, come what might,
For the sake of having you near,
In spite of a warning voice that comes in the night,
And repeats and repeats in my ear,
"Don't you know, little fool, you never can win,
Use your mentality,
Wake up to reality."
But each time I do, just the thought of you
Makes me stop, before I begin,
'Cause I've got you under my skin.

Goodbye, Little Dream, Goodbye

VERSE
I first knew love's delight,
When presto out of the blue,
A dream appeared one night
And whispered, "How do you do?"
I knew I was tempting fate
But I took it straight to my heart.
My fears were right, and now we must part.

REFRAIN
Goodbye, little dream, goodbye,
You made my romance sublime, now it's time to fly,
For the stars have fled from the heavens, the moon's
 deserted the hill,
And the sultry breeze that sang in the trees is suddenly
 strangely still.
It's done, little dream, it's done,

So bid me a fond farewell, we both had our fun.
Was it Romeo or Juliet who said when about to die,
"Love is not all peaches and cream,"
Little dream, goodbye.

Ours

HE: The high gods above
Look down and laugh at our love,
And say to themselves, "How tawdry it's grown."
They've seen our cars
In front of so many bars,
When we should be under the stars,
Together, but alone.
Ours is the chance to make romance our own.

REFRAIN I

HE: Ours, the white Riviera under the moon,
Ours, a gondola gliding on a lagoon,
Ours, a temple serene by the green Arabian Sea,
Or maybe you'd rather be going ga-ga in Gay
 Paree,
Ours, the silent Sierras greeting the dawn,
Or a sun-spotted Devonshire lawn dotted with
 flowers.
Mine, the inclination,
Yours, the inspiration,
Why don't we take a vacation
And make it all ours.

SHE: Don't say "Venice" to me,
 Or suggest that old Riviera,
 Those faded hot spots fill me with gloom somehow.
 As for a Hindu temple, my pet,
 I wouldn't enter one on a bet.
 Why, I'd be afraid of being chased by a sacred cow.
 Don't expect me to dream
 Of the silent Sierras, dear,
 Or to love that fattening cream
 That they give you in Devonshire.
 Don't mention the wilds of Paris,
 Or, as you call it, "Gay Paree."
 I may not be right,
 But New York is quite
 Wild enough for me.

REFRAIN 2

SHE: Ours, the glitter of Broadway, Saturday night,
 Ours, a box at the Garden, watching a fight,
 Ours, the mad brouhaha of the Plaza's Persian
 Room,
 Or, if this fills you with gloom,
 We can go and admire Grant's tomb.
 Ours, a home on the river facing the east,
 Or on one of Park Avenue's least frightening
 tow'rs.
 All the chat you're chattin'
 Sounds to me like Latin,
 Why don't we stay in Manhattan
 And play it's all ours.

Down in the Depths

VERSE
Manhattan—I'm up a tree,
The one I've most adored
Is bored
With me.
Manhattan, I'm awf'lly nice,
Nice people dine with me,
And even twice.
Yet the only one in the world I'm mad about
Talks of somebody else
And walks out.

REFRAIN
With a million neon rainbows burning below me
And a million blazing taxis raising a roar
Here I sit, above the town
In my pet pailletted gown
Down in the depths on the ninetieth floor.
While the crowds at El Morocco punish the parquet
And at "21" the couples clamor for more,
I'm deserted and depressed
In my regal eagle nest
Down in the depths on the ninetieth floor.
When the only one you wanted wants another
What's the use of swank and cash in the bank galore?
Why, even the janitor's wife
Has a perfectly good love life

And here am I
Facing tomorrow
Alone with my sorrow
Down in the depths on the ninetieth floor.

It's De-Lovely

VERSE I

HE: I feel a sudden urge to sing
The kind of ditty that invokes the spring,
So control your desire to curse
While I crucify the verse.

SHE: This verse you've started seems to me
The Tin-Pantithesis of melody,
So spare me, please, the pain,
Just skip the damn thing and sing the refrain.

HE: Mi, mi, mi, mi,
Re, re, re, re,
Do, sol, mi, do, la, si.

SHE: Take it away.

REFRAIN I

The night is young, the skies are clear,
So if you want to go walking, dear,
It's delightful, it's delicious, it's de-lovely.
I understand the reason why
You're sentimental, 'cause so am I,
It's delightful, it's delicious, it's de-lovely.

You can tell at a glance
What a swell night this is for romance,
You can hear dear Mother Nature murmuring low,
"Let yourself go."
So please be sweet, my chickadee,
And when I kiss you, just say to me,
"It's delightful, it's delicious,
It's delectable, it's delirious,
It's dilemma, it's delimit, it's deluxe,
It's de-lovely."

VERSE 2

SHE: Oh, charming sir, the way you sing
 Would break the heart of Missus Crosby's Bing,
 For the tone of your tra la la
 Has that certain je ne sais quoi.
HE: Oh, thank thee kindly, winsome wench,
 But 'stead of falling into Berlitz French
 Just warble to me, please,
 This beautiful strain in plain Brooklynese.
SHE: Mi, mi, mi, mi,
 Re, re, re, re,
 Do, sol, mi, do, la, si.
HE: Take it away.

REFRAIN 2

Time marches on and soon it's plain
You've won my heart and I've lost my brain,
It's delightful, it's delicious, it's de-lovely.
Life seems so sweet that we decide

It's in the bag to get unified,
It's delightful, it's delicious, it's de-lovely.
See the crowd in that church,
See the proud parson plopped on his perch,
Get the sweet beat of that organ, sealing our doom,
"Here goes the groom, boom!"
How they cheer and how they smile
As we go galloping down that aisle.
"It's divine, dear, it's diveen, dear,
It's de-wunderbar, it's de victory,
It's de vallop, it's de vinner, it's de voiks,
It's de-lovely."

REFRAIN 3
The knot is tied and so we take
A few hours off to eat wedding cake,
It's delightful, it's delicious, it's de-lovely.
It feels so fine to be a bride,
And how's the groom? Why, he's slightly fried,
It's delightful, it's delicious, it's de-lovely.
To the pop of champagne,
Off we hop in our plush little plane
Till a bright light through the darkness cozily calls,
"Niag'ra Falls."
All's well, my love, our day's complete,
And what a beautiful bridal suite,
"It's de-reamy, it's de-rowsy,
It's de-reverie, it's de-rhapsody,
It's de-regal, it's de-royal, it's de-Ritz,
It's de-lovely."

We settle down as man and wife
To solve the riddle called "married life,"
It's delightful, it's delicious, it's de-lovely.
We're on the crest, we have no cares,
We're just a couple of honey bears,
It's delightful, it's delicious, it's de-lovely.
All's as right as can be
Till, one night, at my window I see
An absurd bird with a bundle hung on his nose—
"Get baby clo'es."
Those eyes of yours are filled with joy
When Nurse appears and cries, "It's a boy,"
"He's appalling, he's appealing,
He's a pollywog, he's a paragon,
He's a Popeye, he's a panic, he's a pip,
He's de-lovely."

Our boy grows up, he's six feet three,
He's so good-looking, he looks like me,
It's delightful, it's delicious, it's de-lovely.
He's such a hit, this son of ours,
That all the dowagers send him flowers,
It's delightful, it's delicious, it's de-lovely.
So sublime is his press
That in time, L. B. Mayer, no less,
Makes a night flight to New York and tells him he
 should
Go Hollywood.
Good God! today, he gets such pay

That Elaine Barrie's his fiancée,
"It's delightful, it's delicious,
It's delectable, it's delirious,
It's dilemma, it's delimit, it's deluxe,
It's de-lovely."

Ridin' High

VERSE
Love had socked me,
Simply knocked me
For a loop.
Luck had dished me
Till you fished me
From the soup.
Now, together,
We can weather
Anything.
So please don't sputter
If I should mutter:

REFRAIN
Life's great, life's grand,
Future all planned,
No more clouds in the sky.
How'm I ridin'? I'm ridin' high.

Someone I love,
Mad for my love,

So long, Jonah, goodbye.
How'm I ridin'? I'm ridin' high.

Floating on a starlit ceiling,
Doting on the cards I'm dealing,
Gloating, because I'm feeling
So hap-hap-happy,
I'm slap-happy.

So ring bells, sing songs,
Blow horns, beat gongs,
Our love never will die.
How'm I ridin'? I'm ridin' high.

PATTER 1
What do I care
If Missus Harrison Williams is the best-dressed woman
 in town?
What do I care
If Countess Barbara Hutton has a Rolls-Royce built for
 each gown?
Why should I have the vapors
When I read in the papers
That Missus Simpson dined behind the throne?
I've got a cute king of my own.
What do I care
If Katie Hepburn is famous for the world's most
 beautiful nose,
Or if I, for my sins,
Don't possess underpins
Like the pegs "Legs" Dietrich shows?

I'm feeling swell,
In fact so well
It's time some noise began,
For although I'm not
A big shot,
Still, I've got my man.

So ring bells, sing songs,
Blow horns, beat gongs,
Our love never will die.
How'm I ridin'? I'm ridin' high.

PATTER 2
What do I care
If Missus Dorothy Parker has the country's wittiest brain?
What do I care
If little Eleanor Jarrett only swims in vintage champagne?
Why should I be a-flutter
When Republicans mutter
That Missus R. gets pay to write her day,
If I could write my nights, hey, hey!
What do I care
If fair Tallulah possesses tons and tons of jewels from
gents?
Or if someone observes
That I haven't the curves
That Simone Simon presents?
I'm doin' fine,
My life's divine,
I'm living in the sun
'Cause I've a big date

With my fate,
So I rate
A-1.

So ring bells, sing songs,
Blow horns, beat gongs,
Our love never will die.
How'm I ridin'? I'm ridin' high.

Red, Hot and Blue

VERSE
Due to the tragic lowness of my brow,
All music that's highbrow
Gets me upset.
Each time I hear a strain of Stravinsky's,
I hurry to Minsky's
And try to forget.
I don't like Schubert's music or Schumann's,
I'm one of those humans
Who only goes in for Berlin and Vincent Youmans.
I'm for the guy that eludes
Bach sonatas and Chopin preludes.
So when some nice man I meet,
I always murmur tout d'suite:

REFRAIN I
If you want to thrill me and drill me for your crew,
Sing me a melody that's red, hot and blue.

Before you expand on that grand cottage for two,
Sing me a melody that's Red, Hot and Blue,
I can't take Sibelius,
Or Delius,
But I swear I'd throw my best pal away
For Calloway,
So when we're all set and I get married to you,
Don't let that violin
Start playing *Lohengrin*,
It may be sweet as sin
But it's not red, hot and blue.

REFRAIN 2
If you ask me, toots.
Just what puts
Me in a stew,
Sing me a melody that's red, hot and blue.
If I'm quite correct,
You expect
Me to come through,
Sing me a melody that's red, hot and blue.
This craze that's pursuin' me,
May ruin me,
But my Waterloo won't be Wellington
But Ellington.
So if you feel tonight
Like a light
Ev'ning for two,
I've no desire to hear
Flagstad's Brünnhilde, dear,
She waves a pretty spear,
But she's not red, hot and blue.

In the Still of the Night

In the still of the night,
As I gaze from my window
At the moon in its flight,
My thoughts all stray to you.
In the still of the night,
While the world is in slumber,
Oh, the times without number,
Darling, when I say to you,
"Do you love me as I love you?
Are you my life-to-be, my dream come true?"
Or will this dream of mine
Fade out of sight
Like the moon
Growing dim
On the rim
Of the hill
In the chill,
Still
Of the night?

At Long Last Love

VERSE
I'm so in love,
And though it gives me joy intense,
I can't decipher
If I'm a lifer,

Or if it's just a first offense.
I'm so in love,
I've no sense of values left at all.
Is this a playtime,
Affair of Maytime,
Or is it a windfall?

Is it an earthquake or simply a shock?
Is it the good turtle soup or merely the mock?
Is it a cocktail—this feeling of joy,
Or is what I feel the real McCoy?
Have I the right hunch or have I the wrong?
Will it be Bach I shall hear or just a Cole Porter song?
Is it a fancy not worth thinking of,
Or is it at long last love?

REFRAIN 2
Is it the rainbow or just a mirage?
Will it be tender and sweet or merely massage?
Is it a brainstorm in one of its quirks,
Or is it the best, the crest, the works?
Is it for all time or simply a lark?
Is it the Lido I see or only Asbury Park?
Should I say "Thumbs down" and give it a shove,
Or is it at long last love?

REFRAIN 3
Is it a breakdown or is it a break?
Is it a real Porterhouse or only a steak?
What can account for these strange pitter-pats?

Could this be the dream, the cream, the cat's?
Is it to rescue or is it to wreck?
Is it an ache in the heart or just a pain in the neck?
Is it the ivy you touch with a glove,
Or is it at long last love?

REFRAIN (UNFINISHED)
Is it in marble or is it in clay?
Is what I thought a new Rolls, a used Chevrolet?
Is it a sapphire or simply a charm?
Is it ——— or just a shot in the arm?
Is it today's thrill or really romance?
Is it a kiss on the lips or just a kick in the pants?
Is it the gay gods cavorting above,
Or is it at long last love?

Get Out of Town

VERSE
The farce was ended,
The curtain drawn,
And I at least pretended
That love was dead and gone.
But now from nowhere
You come to me as before,
To take my heart
And break my heart
Once more.

Get out of town,
Before it's too late, my love.
Get out of town,
Be good to me, please
Why wish me harm?
Why not retire to a farm
And be contented to charm
The birds off the trees?
Just disappear,
I care for you much too much,
And when you are near,
Close to me, dear,
We touch too much.
The thrill when we meet
Is so bittersweet
That, darling, it's getting me down,
So on your mark, get set,
Get out of town.

My Heart Belongs to Daddy

VERSE
I used to fall
In love with all
Those boys who maul
Refined ladies.
But now I tell
Each young gazelle

To go to hell—
I mean, Hades,
For since I've come to care
For such a sweet millionaire.

REFRAIN 1
While tearing off
A game of golf
I may make a play for the caddy.
But when I do
I don't follow through
'Cause my heart belongs to Daddy.
If I invite
A boy, some night,
To dine on my fine finnan haddie,
I just adore
His asking for more,
But my heart belongs to Daddy.
Yes, my heart belongs to Daddy,
So I simply couldn't be bad.
Yes, my heart belongs to Daddy,
Da-da, da-da-da, da-da-da, dad!
So I want to warn you, laddie,
Tho' I know you're perfectly swell,
That my heart belongs to Daddy
'Cause my Daddy, he treats me so well.
He treats it and treats it,
And then he repeats it,
Yes, Daddy, he treats it so well.

Saint Patrick's Day,
Although I may
Be seen wearing green with a paddy,
I'm always sharp
When playing the harp,
'Cause my heart belongs to Daddy.
Though other dames
At football games
May long for a strong undergraddy,
I never dream
Of making the team
'Cause my heart belongs to Daddy.
Yes, my heart belongs to Daddy,
So I simply couldn't be bad.
Yes, my heart belongs to Daddy,
Da-da, da-da-da, da-da-da, dad!
So I want to warn you, laddie,
Tho' I simply hate to be frank,
That I can't be mean to Daddy
'Cause my Da-da-da-daddy might spank.
In matters artistic
He's not modernistic
So Da-da-da-daddy might spank.

I Concentrate on You

Whenever skies look gray to me
And trouble begins to brew,
Whenever the winter winds become too strong,

I concentrate on you.
When Fortune cries, "Nay, nay!" to me
And people declare, "You're through,"
Whenever the blues become my only song,
I concentrate on you,
On your smile so sweet, so tender,
When at first my kiss you decline,
On the light in your eyes when you surrender
And once again our arms intertwine.
And so when wise men say to me
That love's young dream never comes true,
To prove that even wise men can be wrong,
I concentrate on you,
I concentrate
And concentrate
On you.

But in the Morning, No

VERSE

HE: Love affairs among gentility
 Hit the rocks with great agility
 Either because of income or incompatibility.

SHE: We've adjusted our finances,
 You run mine and I run France's,
 So there's only one question that's hot,
 Will we have fun or not?

SHE: Are you fond of riding, dear?
Kindly tell me, if so.

HE: Yes, I'm fond of riding, dear,
But in the morning, no.

SHE: Are you good at shooting, dear?
Kindly tell me, if so.

HE: Yes, I'm good at shooting, dear,
But in the morning, no.
When the dawn's early light
Comes to crucify my night,
That's the time
When I'm
In low.

SHE: Are you fond of wrestling, dear?
Kindly tell me, if so.

HE: Yes, I'm fond of wrestling, dear,
But in the morning, no, no—no, no,
No, no, no, no, no!

REFRAIN 2

HE: Do you like the mountains, dear?
Kindly tell me, if so.

SHE: Yes, I like the mountains, dear,
But in the morning, no.

HE: Are you good at climbing, dear?
Kindly tell me, if so.

SHE: Yes, I'm good at climbing, dear,
But in the morning, no.
When the light of the day
Comes and drags me from the hay,
That's the time

When I'm
In low.

HE: Have you tried Pike's Peak, my dear?
Kindly tell me, if so.

SHE: Yes, I've tried Pike's Peak, my dear,
But in the morning, no, no—no, no,
No, no, no, no, no!

REFRAIN 3

SHE: Are you fond of swimming, dear?
Kindly tell me, if so.

HE: Yes, I'm fond of swimming, dear,
But in the morning, no.

SHE: Can you do the crawl, my dear?
Kindly tell me, if so.

HE: I can do the crawl, my dear,
But in the morning, no.
When the sun through the blind
Starts to burn my poor behind
That's the time
When I'm
In low.

SHE: Do you use the breast stroke, dear?
Kindly tell me, if so.

SHE: Yes, I use the breast stroke, dear,
But in the morning, no, no—no, no,
No, no, no, no, no!

REFRAIN 4

HE: Are you fond of Hot Springs, dear?
Kindly tell me, if so.

SHE: Yes, I'm fond of Hot Springs, dear,
But in the morning, no.

HE: D'you like old Point Comfort, dear?
Kindly tell me, if so.

SHE: I like old Point Comfort, dear,
But in the morning, no.
When my maid toddles in
With my orange juice and gin,
That's the time
When I'm
In low.

HE: Do you like Mi-ami, dear?
Kindly tell me, if so.

SHE: Yes, I like your-ami, dear,
But in the morning, no, no—no, no,
No, no, no, no, no!

REFRAIN 5

SHE: Are you good at figures, dear?
Kindly tell me, if so.

HE: Yes, I'm good at figures dear,
But in the morning, no.

SHE: D'you do double entry, dear?
Kindly tell me, if so.

HE: I do double entry, dear,
But in the morning, no.
When the sun on the rise
Shows the bags beneath my eyes,
That's the time
When I'm
In low.

SHE: Are you fond of business, dear?
 Kindly tell me, if so.
HE: Yes, I'm fond of business, dear,
 But in the morning, no, no—no, no,
 No, no, no, no, no!

REFRAIN 6

HE: Are you in the market, dear?
 Kindly tell me, if so.
SHE: Yes, I'm in the market, dear,
 But in the morning, no.
HE: Are you fond of bulls and bears?
 Kindly tell me, if so.
SHE: Yes, I'm fond of bears and bulls,
 But in the morning, no.
 When I'm waked by my fat
 Old canary, singing flat,
 That's the time
 When I'm
 In low.
HE: Would you ever sell your seat?
 Kindly tell me, if so.
SHE: Yes, I'd gladly sell my seat,
 But in the morning, no, no—no, no,
 No, no, no, no, no!

REFRAIN 7

SHE: Are you fond of poker, dear?
 Kindly tell me, if so.
HE: Yes, I'm fond of poker, dear,
 But in the morning, no.

SHE: Do you ante up, my dear?
Kindly tell me, if so.

HE: Yes, I ante up my dear,
But in the morning, no.
When my old Gunga Din
Brings the Bromo Seltzer in,
That's the time
When I'm
In low.

SHE: Can you fill an inside straight?
Kindly tell me, if so.

HE: I've filled plenty inside straight,
But in the morning, no, no—no, no,
No, no, no, no, no!

REFRAIN 8

HE: Are you fond of Democrats?
Kindly tell me, if so.

SHE: Yes, I'm fond of Democrats,
But in the morning, no.

HE: Do you like Republicans?
Kindly tell me, if so.

SHE: Yes, I like Republi-cans,
But in the morning, no.
When my pet Pekinese
Starts to cross his Q's and P's.
That's the time
When I'm
In low.

HE: Do you like third parties, dear?
Kindly tell me, if so.

SHE: Yes, I love third parties, dear,
But in the morning, no, no—no, no,
No, no, no, no, no!

Well, Did You Evah!

HE: When you're out in smart society
And you suddenly get bad news,
You mustn't show anxiety
SHE: And proceed to sing the blues.
HE: For example, tell me something sad,
Something awful, something grave,
And I'll show you how a Racquet Club lad
Would behave.

SHE: Have you heard the coast of Maine
Just got hit by a hurricane?
HE: Well, did you evah!
What a swell party this is.
SHE: Have you heard that poor, dear Blanche
Got run down by an avalanche?
HE: Well, did you evah!
What a swell party this is.
It's great, it's grand.
It's Wonderland!
It's tops, it's first.
It's DuPont, it's Hearst!

What soup, what fish.
That meat, what a dish!
What salad, what cheese!

SHE: Pardon me one moment, please,
Have you heard that Uncle Newt
Forgot to open his parachute?

HE: Well, did you evah!
What a swell party this is.

SHE: Old Aunt Susie (Miss Pringle) just came back
With her child and the child is black.

HE: Well, did you evah!
What a swell party this is.

REFRAIN 2

HE: Have you heard it's in the stars
Next July we collide with Mars?

SHE: Well, did you evah!
What a swell party this is.

HE: Have you heard that Grandma Doyle
Thought the Flit was her mineral oil?

SHE: Well, did you evah!
What a swell party this is.
What daiquiris!
What sherry! Please!
What Burgundy!
What great Pommery!
What brandy, wow!
What whiskey, here's how!
What gin and what beer!

HE: Will you sober up, my dear?
Have you heard Professor Munch
Ate his wife and divorced his lunch?

SHE: Well, did you evah!
 What a swell party this is.
 HE: Have you heard that Mimsie Starr
 Just got pinched in the Astor Bar?
SHE: Well, did you evah!
 What a swell party this is!

REFRAIN 3

SHE: Have you heard that poor old Ted
 Just turned up in an oyster bed?
 HE: Well, did you evah!
 What a swell party this is.
SHE: Lily Lane has lousy luck,
 She was there when the light'ning struck.
 HE: Well, did you evah!
 What a swell party this is.
 It's fun, it's fine,
 It's too divine.
 It's smooth, it's smart.
 It's Rodgers, it's Hart!
 What debs, what stags!
 What gossip, what gags!
 What feathers, what fuss!
SHE: Just between the two of us,
 Reggie's rather scatterbrained,
 He dove in when the pool was drained.
 HE: Well, did you evah!
 What a swell party this is.
SHE: Mrs. Smith in her new Hup
 Crossed the bridge when the bridge was up.
 HE: Well, did you evah!
 What a swell party this is!

HE: Have you heard that Mrs. Cass
 Had three beers and then ate the glass?

SHE: Well, did you evah!
 What a swell party this is.

HE: Have you heard that Captain Craig
 Breeds termites in his wooden leg?

SHE: Well, did you evah!
 What a swell party this is.
 It's fun, it's fresh,
 It's post-Depresh.
 It's Shangri-la.
 It's *Harper's Bazaar*!
 What clothes, quel chic!
 What pearls, they're the peak!
 What glamour, what cheer!

HE: This will simply slay you, dear,
 Kitty isn't paying calls,
 She slipped over Niagara Falls.

SHE: Well, did you evah!
 What a swell party this is.

HE: Have you heard that Mayor Hague
 Just came down with bubonic plague?

SHE: Well, did you evah!
 What a swell party this is.

Katie Went to Haiti

Katie went to Haiti,
Stopped off for a rest.
Katie met a natie,
Katie was impressed.
After a week in Haiti
She started to go away,
Then Katie met another natie,
So Katie prolonged her stay.
After a month in Haiti
She decided to resume her trip,
But Katie met still another natie
And Katie missed the ship.
So Katie lived in Haiti,
Her life there, it was great,
'Cause Katie knew her Haiti
And practically all Haiti knew Katie.

REFRAIN 2
Katie stayed in Haiti
Spending all her pay.
Katie met a natie
Ev'ry other day.
Katie would tell the natie
That Katie was out for thrills.
Each natie got a few for Katie
And Katie, she got the bills.
After a year in Haiti
She decided she should really go

But Katie had lived at such a ratie
That Katie had no dough.
So Katie stuck to Haiti
Delighted with her fate,
'Cause Katie still had Haiti
And practically all Haiti had Katie.

REFRAIN 3
Katie looked at Haiti
Feeling rather tired.
Katie met a natie,
Katie was inspired.
After another natie
She sat down and wrote a book,
A guidebook for visitors to Haiti
Called "Listen, Stop, and Look!"
After the book by Katie
Had been published in the U.S.A.
The ratie of tourist trade in Haiti
Got bigger ev'ry day.
When Katie died at eighty
They buried her in state,
For Katie made her Haiti
And practically all Haiti made Katie.

I've Still Got My Health

I wasn't born to stately halls
Of alabaster,
I haven't given many balls
For Missus Astor,
But all the same, I'm in the pink,
My constitution's made of zinc
And you never have to give this goil
Oil castor.

I'm always a flop at a top-notch affair,
But I've still got my health, so what do I care!
My best ring, alas, is a glass solitaire,
But I've still got my health, so what do I care!
By fashion and fopp'ry
I'm never discussed,
Attending the op'ry,
My box would be a bust!
When I give a tea, Lucius Beebe ain't there,
Well, I've still got my health, so what do I care!

In spite of my Lux movie skin
And Brewster body,
I've never joined the harem in
Scheherazade,
But, if so far, I've been a bust,
I'm stronger than the Bankers Trust

And you never have to give *this* one
Hunyadi.

REFRAIN 2
No rich Vanderbilt gives me gilt underwear,
But I've still got my health, so what do I care!
I've never been dined by refined L.B. Mayer,
But I've still got my health, so what do I care!
When Barrymore, he played
With his wife of yore,
The lead Missus B played,
But I played Barrymore,
Elaine kicked me out, with a clout, you know where,
Well, I've still got my health, so what do I care!

REFRAIN 3
I haven't the face of Her Grace, Ina Claire,
But I've still got my health, so what do I care!
I can't count my ribs, like His Nibs, Fred Astaire,
But I've still got my health, so what do I care!
Once I helped Jock Whitney
And as my reward,
I asked for a Jitney—
In other words, a Ford,
What I got from Jock was a sock, you know where,
Well, I've still got my health, so what do I care!

REFRAIN 4
When I'm in New York, I'm the Stork Club's despair,
But I've still got my health, so what do I care!
No radio chain wants my brain on the air,
But I've still got my health, so what do I care!

At school I was noted
For my lack of speed,
In fact I was voted
"Least likely to succeed,"
My wisecracks, I'm told, are like old Camembert,
Well, I've still got my health, so what do I care!

REFRAIN 5

ENSEMBLE: She never will have that Park Avenue air,
HATTIE: But why should I weep?
Or toss in my sleep.
'Cause, I've still got my health, so what do I
care!

VERSE 3

When Broadway first reviewed this wench,
The Press was catty,
They all agreed I'd even stench
In Cincinnati.
But if I laid an awful egg,
I'm still as hot as Mayor Hague,
So in case you want to start a fire,
Wire Hattie.

REFRAIN 6

The hip that I shake doesn't make people stare,
But I've still got my health, so what do I care!
The sight of my props never stops thoroughfare,
But I've still got my health, so what do I care!
I knew I was slipping
At Minsky's one dawn,
When I started stripping,

They hollered, "Put it on!"
Just once Billy Rose let me pose in the bare,
Well, I've still got my vitamins A, B, C, D,
E, F, G, H,
I
Still have my
Health.

I'm Throwing a Ball Tonight

VERSE
My life was simply hellish,
I didn't stand a chance,
I thought that I would relish
A tomb like General Grant's,
But now I feel so swellish,
So Elsa Maxwell-ish,
That I'm giving a dance.

REFRAIN
I feel like a million dollars,
I feel simply out o' sight,
So come on down, come on down,
I'm throwing a ball tonight.
I'm full of the old paprika,
I'm loaded with dynamite,
So come on down, come on down,
I'm throwing a ball tonight.
A certain person just brought some news,

And wow, was it great!
So I'm rehearsin' my dancin' shoes
'Cause now, I can celebrate.
I feel like a million dollars,
I feel simply out o' sight,
So come on down, come on down,
I'm throwing a ball tonight.

PATTER I
I invited Wendell Willkie,
I invited F.D.R.,
And for photographs,
I asked the staffs
Of *Life*, *Look*, *Peek*, *Pic*, *Snap*, *Click*, and *Harper's Bazaar*.
I invited Monty Woolley
And of course I asked Cliff Odets,
But to my surprise
Ev'ry one of those guys
Tendered his regrets.
And so I
Feel like a million dollars,
I feel simply out o' sight,
So come on down, come on down,
I'm throwing a ball tonight.

PATTER 2 (1ST VERSION)
I invited Gov'nor Lehman,
And Commishner Valentine,
And to do their stunts
I asked the Lunts

And Grace Moore, Bert Lahr, Mae West, and Father
 Divine.
I invited Gracie Allen
And of course I asked Fanny Brice.
But to all my bids
Ev'ry one of those kids
Wired back,
"No dice!"

PATTER 2 (2ND VERSION)
I've arranged a rhumba contest,
Just to make the party chic
And the winning ones
Will get two tons
Of Lux, Ponds, Teel, Squibbs, Mum, Zip, and
 Campho-phenique.
I invited Johnnie Walker
And Haig and Haig I asked twice,
But to all my bids
Ev'ry one of those kids
Wired back,
"No dice!"
And so I
Feel like a million dollars,
I feel simply out o' sight,
So come on down, come on down,
Come on down,
Come on down,
Come on down,
I'm feeling magnific,
I'm throwing a turr-ific
Ball . . . tonight.

Make It Another Old-Fashioned, Please

VERSE

Since I went on the wagon, I'm
Certain drink is a major crime,
For when you lay off the liquor
You feel so much slicker,
Well, that is, most of the time.
But there are moments,
Sooner or later,
When it's tough, I've got to say,
Not to say:
Waiter,

REFRAIN I

Make it another old-fashioned, please,
Make it another double old-fashioned, please,
Make it for one who's due
To join the disillusioned crew,
Make it for one of love's new
Refugees.
Once, high in my castle, I reigned supreme,
And oh! what a castle built on a heavenly dream,
Then quick as a lightning flash,
That castle began to crash,
So make it another old-fashioned, please.

REFRAIN 2

Make it another old-fashioned, please,
Make it another double old-fashioned, please,
Make it for one who's due

To join the disillusioned crew,
Make it for one of love's new
Refugees.
Once I owned a treasure, so rare, so pure,
The greatest of treasures, happiness safe and secure,
But like ev'ry hope too rash,
My treasure, I find, is trash,
So make it another old-fashioned, please.
Leave out the cherry,
Leave out the orange,
Leave out the bitters,
Just make it a straight rye!

Dream-Dancing

VERSE
When shades enfold
The sunset's gold
And stars are bright above again,
I smile, sweetheart,
For then I know I can start
To live again, to love again.

REFRAIN
When day is gone
And night comes on,
Until the dawn
What do I do?
I clasp your hand
And wander through slumberland,

Dream-dancing with you.
We dance between
A sky serene
And fields of green,
Sparkling with dew.
It's joy sublime
Whenever I spend my time
Dream-dancing with you.
Dream-dancing,
Oh, what a lucky windfall!
Touching you, clutching you, all
The night through,
So say you love me, dear,
And let me make my career
Dream-dancing,
To paradise prancing,
Dream-dancing with you.

Since I Kissed My Baby Goodbye

VERSE
Oh, what nights, glory be,
When my baby and me
Used to ramble lovers' lane
From sundown to dawn.
Then a voodoo, I guess,
Put the jinx on our happiness,
And the mockin'bird's refrain
Is done dead and gone.

Evenin', creepin' down the mountain,
Wakes up Mister Firefly,
Bullfrog, settin' there,
Starts a-croakin', but I don't care,
Since I kissed my baby goodbye.
South wind shakes the ole magnolia,
Moon-man lights the dingy sky,
Stars start sprinklin' gold
On the river, but still I'm cold
Since I kissed my baby goodbye.
Since my baby and me
Parted company,
I can't see what's the diff if I live or I die.
Oh, Lawd, I'm takin' such a beatin',
I'm no good, even cheatin',
Since I kissed my baby goodbye.

So Near and Yet So Far

VERSE

I so often dream
We might make a team,
But so wild a scheme
I must banish,
For each time I start
To open my heart
You vanish.
We might find some isle

Where lotuses smile
And our time beguile
Going native,
But how can we go
Unless you are co-
Operative?

My dear, I've a feeling you are
So near and yet so far,
You appear like a radiant star,
First so near, then again so far.
I just start getting you keen on clinches galore with me,
When fate steps in on the scene and mops up the floor
 with me.
No wonder I'm a bit under par,
For you're so near and yet so far.
My condition is only so-so,
'Cause whenever I feel you're close, oh,
You turn out to be, oh, so
Far.

Let's Not Talk About Love

VERSE I

MAGGIE: Relax for one moment, my Jerry,
 Come out of your dark monastery,
 While Venus is beaming above.
 Darling, let's talk about love.

Let's talk about love, that wonderful thing,
Let's blend the scent of Venice with Paris in spring,
Let's gaze at that moon and try to believe
We're Venus and Adonis, or Adam and Eve,
Let's throw away anxiety, let's quite forget propriety,
Respectable society, the rector and his piety,
And contemplate l'amour in all its infinite variety,
My dear, let's talk about love.
Pretend you're Chopin and I'll be George Sand.
We're on the Grand Canal and, oh, baby, it's grand!
Let's mention Walküres and helmeted knights,
I'm beautiful Brünnhilde, you're Siegfried in tights,
Let's curse the asininity of trivial consanguinity,
Let's praise the masculinity of Dietrich's new affinity,
Let's picture Cleopatra saying "Scram" to her virginity,
My dear, let's talk about love.
The weather's so warm and you are so cute,
Let's dream about Tahiti and tropical fruit,
I've always said men were simply deevine
(Did you know that Peggy Joyce was once a pupil of
 mine?).
Let's gather miscellanea on Oberon's Titania,
Or ladies even brainier who've moved to Pennsylvania
(Bucks County, so I hear, is just a nest of nymphomania),
My dear, let's talk about love.

VERSE 2

JERRY: My buddies all tell me selectees
 Are expected by ladies to neck-tease,
 I could talk about love and why not?

But believe me, it wouldn't be so hot,
So—

REFRAIN 2

Let's talk about frogs, let's talk about toads,
Let's try to solve the riddle why chickens cross roads,
Let's talk about games, let's talk about sports,
Let's have a big debate about ladies in shorts,
Let's question the synonymy of freedom and autonomy,
Let's delve into astronomy, political economy,
Or if you're feeling biblical, the book of Deuteronomy,
But let's not talk about love.
Let's ride the New Deal, like Senator Glass,
Let's telephone to Ickes and order more gas,
Let's curse the Old Guard and Hamilton Fish,
Forgive me, dear, if Fish is your favorite dish.
Let's heap some hot profanities on Hitler's inhumanities,
Let's argue if insanity's the cause of his inanities,
Let's weigh the Shubert Follies with the Ear-rl Carroll
 Vanities,
But let's not talk about love.
Let's talk about drugs, let's talk about dope,
Let's try to picture Paramount minus Bob Hope,
Let's start a new dance, let's try a new step,
Or investigate the cause of Missus Roosevelt's pep,
Why not discuss, my dee-arie,
The life of Wallace Bee-ery
Or bring a jeroboam on
And write a drunken poem on
Astrology, mythology,
Geology, philology,

Pathology, psychology,
Electro-physiology,
Spermology, phrenology?
I owe you an apology,
But let's not talk about love.

Let's speak of Lamarr, that Hedy so fair,
Why does she let Joan Bennett wear all her old hair?
If you know Garbo, then tell me this news,
Is it a fact the Navy's launched all her old shoes?
Let's check on the veracity of Barrymore's bibacity
And why his drink capacity should get so much publacity,
Let's even have a huddle over Ha'vard Univassity,
But let's not talk about love.
Let's wish him good luck, let's wish him more pow'r,
That Fiorella fella, my favorite flow'r,
Let's get some champagne from over the seas,
And drink to Sammy Goldwyn,
Include me out please.
Let's write a tune that's playable, a ditty swing-and-
 swayable
Or say whatever's sayable, about the Tow'r of Ba-abel,
Let's cheer for the career of itty-bitty Betty Gra-abel,
But let's not talk about love.
In case you play cards, I've got some right here,
So how about a game o' gin rummy, my dear?
Or if you feel warm and bathin's your whim,
Let's get in the all-together and enjoy a short swim,
No, honey, ah suspect you-all
Of bein' intellectual

And so, instead of gushin' on,
Let's have a big discussion on
Timidity, stupidity, solidity, frigidity,
Avidity, turbidity, Manhattan, and viscidity,
Fatality, morality, legality, finality,
Neutrality, reality, or Southern hospitality,
Pomposity, verbosity,
You're losing your velocity,
But let's not talk about love.

You'd Be So Nice To Come Home To

VERSE I

HE: It's not that you're fairer
Than a lot of girls just as pleasin'
That I doff my hat
As a worshipper at
Your shrine.
It's not that you're rarer
Than asparagus out of season,
No, my darling, this is the reason
Why you've got to be mine:

REFRAIN

You'd be so nice to come home to,
You'd be so nice by the fire,
While the breeze on high
Sang a lullaby,
You'd be all that I
Could desire.

Under stars chilled by the winter,
Under an August moon burning above,
You'd be so nice,
You'd be paradise
To come home to and love.

VERSE 2
SHE: I should be excited,
 But, Lothario, why not own up
 That you always chase
 After ev'ry new face
 In town?
 I would be delighted
 If we two could, some day, be sewn up,
 For if you behaved like a grown-up
 And could only slow down.

REPEAT REFRAIN

I Love You

VERSE
If a love song I could only write,
A song with words and music divine,
I would serenade you ev'ry night
Till you'd relent and consent to be mine.
But alas, just an amateur am I,
And so I'll not be surprised, my dear,
If you smile and politely pass it by
When this, my first love song, you hear:

"I love you,"
Hums the April breeze.
"I love you,"
Echo the hills.
"I love you,"
The golden dawn agrees
As once more she sees
Daffodils.
It's spring again
And birds, on the wing again,
Start to sing again
The old melody.
"I love you,"
That's the song of songs,
And it all belongs
To you and me.

Ev'ry Time We Say Goodbye

VERSE

We love each other so deeply
That I ask you this, sweetheart,
Why should we quarrel ever,
Why can't we be enough clever
Never to part?

Ev'ry time we say goodbye
I die a little,
Ev'ry time we say goodbye
I wonder why a little,
Why the gods above me
Who must be in the know
Think so little of me
They allow you to go.
When you're near there's such an air
Of spring about it,
I can hear a lark somewhere
Begin to sing about it.
There's no love song finer
But how strange
The change
From major to minor
Ev'ry time we say goodbye,
Ev'ry single time we say goodbye.

I Wrote a Play

I wrote a play
And it took me many a day,
It took me many a month, hear, hear!
It took me many a hungry year,
Yet I still thrill when I say
That I wrote a play.

When I finished my play
I said to myself one day,
"It must have a title with sweep and swirl."
Then I suddenly thought of it, "Boy Loves Girl,"
So "Boy Loves Girl" right away
Became the name of my play.

Then I packed my play
And carried it quick to Broadway,
Where I dug up a millionaire friend of mine,
Who took Gilbert Miller somewhere to dine
And filled the great gourmet so full of feed
That finally Gilbert agreed to read,
Without a moment's delay,
"Boy Loves Girl," my pearl of a play.

A year passed and a day,
Then Gilbert phoned me to say,
"I think your play is excellent stuff,
But hardly European enough,
Yet with slight alterations it ought to go far,
So it's being rewritten by Shaw and Molnár
And I'm changing the title from 'Boy Loves Girl'
To 'Hungarian Princess Loves British Earl.'"
So I went to his office that day
And stole my pretty play away.

I next took my play
To the Theatre Guild, heigh, heigh!
They read it and said, "It's charming stuff,
But, of course, for the Guild not long enough,
So Eugene O'Neill will rewrite the whole thing

And when it's longer than Wagner's Ring
We'll start rehearsing your play at once
As we've simply got to revive the Lunts,
But as 'Boy Loves Girl' doesn't quite fit in,
We have changed the title to 'Alfred Loves Lynn.'"
So I rushed to their office that day
And snatched my darling play away.

Then heavy-hearted I trod
With my play to Michael Todd.
He read it and said, "It's terrific stuff,
But for Broadway it ain't big and dirty enough,
Still I'm gonna produce it, just for a lark,
I'm taking the Mall in Central Park,
It's being rewritten by Gypsy Rose,
I'm hiring a nudist to do the clo'es,
The cast will consist of Man Mountain Dean
And a boatload of babes from the Argentine,
And I've changed the title, so help me God,
To 'The Love Life of Michael Todd.'"
So I ran to his office that day
And plucked my precious play away.

Then I sent to the coast my play,
And Sam Goldwyn phoned me to say,
"Hello, my boy, and au revoir,
Now listen slowly and have a cigar.
Your lousy play is a stinkeroo,
I just read part of it all the way through,
But I like the title extremely much,
Somehow 'Boy Loves Girl' has the Goldwyn touch.
Now I've bought a play that was tough to get

Called 'Romeo and Juliet,'
But if the title was 'Boy Loves Girl'
What a helluva picture for Milton Berle!
And if you'll sell me that title, by heck,
I'll wire you at once a blanket check."
So I sold him the title that day
And that's what became of my play,
Yes, that's what became of my play.

Be a Clown

VERSE
I'll remember forever,
When I was but three,
Mama, who was clever,
Remarking to me:
If, son, when you're grown up,
You want ev'rything nice,
I've got your future sewn up
If you take this advice:

REFRAIN I
Be a clown, be a clown,
All the world loves a clown.
Act the fool, play the calf,
And you'll always have the last laugh.
Wear the cap and the bells
And you'll rate with all the great swells.
If you become a doctor, folks'll face you with dread,
If you become a dentist, they'll be glad when you're dead,

You'll get a bigger hand if you can stand on your head,
Be a clown, be a clown, be a clown.

Be a clown, be a clown,
All the world loves a clown.
Be a crazy buffoon
And the demoiselles'll all swoon.
Dress in huge, baggy pants
And you'll ride the road to romance.
A butcher or a baker, ladies never embrace,
A barber for a beau would be a social disgrace,
They all'll come to call if you can fall on your face,
Be a clown, be a clown, be a clown.

Be a clown, be a clown,
All the world loves a clown.
Show 'em tricks, tell 'em jokes
And you'll only stop with top folks.
Be a crack jackanapes
And they'll imitate you like apes.
Why be a great composer with your rent in arrears,
Why be a major poet and you'll owe it for years,
When crowds'll pay to giggle if you wiggle your ears?
Be a clown, be a clown, be a clown.

Be a clown, be a clown,
All the world loves a clown.
If you just make 'em roar
Watch your mountebank account soar.

Wear a painted mustache
And you're sure to make a big splash.
A college education I should never propose,
A bachelor's degree won't even keep you in clo'es,
But millions you will win if you can spin on your nose.
Be a clown, be a clown, be a clown.

REFRAIN 5
Be a clown, be a clown,
All the world loves a clown.
Be the poor silly ass
And you'll always travel first-class,
Give 'em quips, give 'em fun,
And they'll pay to say you're A-1.
If you become a farmer, you've the weather to buck,
If you become a gambler, you'll be stuck with your luck,
But jack you'll never lack if you can quack like a duck
(Quack, quack, quack, quack).
Be a clown, be a clown, be a clown.

Another Op'nin', Another Show

Another op'nin', another show
In Philly, Boston or Baltimo',
A chance for stage folks to say hello,
Another op'nin' of another show.
Another job that you hope, at last,
Will make your future forget your past,
Another pain where the ulcers grow,
Another op'nin' of another show.

Four weeks, you rehearse and rehearse,
Three weeks, and it couldn't be worse,
One week, will it ever be right?
Then out o' the hat, it's that big first night!
The overture is about to start,
You cross your fingers and hold your heart,
It's curtain time and away we go!
Another op'nin',
Just another op'nin' of another show.

So in Love

Strange, dear, but true, dear,
When I'm close to you, dear,
The stars fill the sky,
So in love with you am I.
Even without you
My arms fold about you.
You know, darling, why,
So in love with you am I.
In love with the night mysterious
The night when you first were there,
In love with my joy delirious
When I knew that you could care.
So taunt me and hurt me,
Deceive me, desert me,
I'm yours 'til I die,
So in love,
So in love,
So in love with you, my love, am I.

I've Come to Wive It Wealthily in Padua

I've come to wive it wealthily in Padua,
If wealthily then happily in Padua.
If my wife has a bag of gold,
Do I care if the bag be old?
I've come to wive it wealthily in Padua.

I've come to wive it wealthily in Padua.
I heard you mutter, "Zounds, a loathsome lad you are."
I shall not be disturbed one bit
If she be but a quarter-wit,
If she only can talk of clo'es
While she powders her goddamned nose,
I've come to wive it wealthily in Padua.

I've come to wive it wealthily in Padua.
I heard you say, "Gadzooks, completely mad you are!"
'Twouldn't give me the slightest shock
If her knees now and then should knock,
If her eyes were a wee bit crossed,
Were she wearing the hair she'd lost,
Still the damsel I'll make my dame,
In the dark they are all the same,
I've come to wive it wealthily in Padua.

I've come to wive it wealthily in Padua.
I heard you say, "Good gad, but what a cad you are!"
Do I mind if she fret and fuss,
If she fume like Vesuvius,
If she roar like a winter breeze

On the rough Adriatic seas,
If she scream like a teething brat,
If she scratch like a tiger cat,
If she fight like a raging boar,
I have oft stuck a pig before,
I've come to wive it wealthily in Padua.
With a hunny, nunny, nunny,
And a hey, hey, hey,
Not to mention money, money
For a rainy day,
I've come to wive it wealthily in Padua.

I Hate Men

REFRAIN I
I hate men.
I can't abide 'em even now and then.
Than ever marry one of them, I'd rest a virgin rather,
For husbands are a boring lot and only give you bother.
Of course, I'm awfly glad that Mother had to marry
 Father,
But I hate men.
I hate 'em all, from modern man 'way back to Father
 Adam,
He sired Cain and Abel though the Lord above forbade
 'em,
I'd hate both Cain and Abel though Betty Grable had 'em,
Oh, I hate men!

I hate men.

They should be kept like piggies in a pen.

You may be wooed by Jack the Tar, so charming and so
　　chipper,

But if you take him for a mate, be sure that you're the
　　skipper,

For Jack the Tar can go too far. Remember Jack the
　　Ripper?

Oh, I hate men.

Of all the types I've ever met within our democracy,

I hate the most the athlete with his manner bold and
　　brassy,

He may have hair upon his chest but, sister, so has Lassie.

Oh, I hate men!

I hate men.

Their worth upon this earth I dinna ken.

Avoid the trav'ling salesman though a tempting Tom he
　　may be,

From China he will bring you jade and perfume from
　　Araby,

But don't forget 'tis he who'll have the fun and thee the
　　baby,

Oh, I hate men.

If thou shouldst wed a businessman, be wary, oh, be wary.

He'll tell you he's detained in town on business necessary,

His bus'ness is the bus'ness which he gives his secretary,

Oh, I hate men!

I hate men.

Though roosters they, I will not play the hen.

If you espouse an older man through girlish optimism,

He'll always stay at home at night and make no criticism,

Though you may call it love, the doctors call it
rheumatism.

Oh, I hate men.

From all I've read, alone in bed, from A to Zed, about
'em.

Since love is blind, then from the mind, all womankind
should rout 'em,

But, ladies, you must answer too, what would we do
without 'em?

Still, I hate men!

Were Thine That Special Face

VERSE

I wrote a poem

In classic style.

I wrote it with my tongue in my cheek

And my lips in a smile.

But of late my poem

Has a meaning so new,

For to my surprise

It suddenly applies

To my darling—to you.

Were thine that special face
The face which fills my dreaming,
Were thine the rhythm'd grace,
Were thine the form so lithe and slender,
Were thine the arms so warm, so tender,
Were thine the kiss divine,
Were thine the love for me,
The love which fills my dreaming,
When all these charms are thine
Then you'll be mine, all mine.

Too Darn Hot

VERSE I

It's too darn hot,
It's too darn hot.
I'd like to sup with my baby tonight,
And play the pup with my baby tonight.
I'd like to sup with my baby tonight,
And play the pup with my baby tonight,
But I ain't up to my baby tonight,
'Cause it's too darn hot.

It's too darn hot,
It's too darn hot.
I'd like to stop for my baby tonight,
And blow my top with my baby tonight.
I'd like to stop for my baby tonight,

And blow my top with my baby tonight,
But I'd be a flop with my baby tonight,
'Cause it's too darn hot.

It's too darn hot,
It's too darn hot.
I'd like to fool with my baby tonight,
Break ev'ry rule with my baby tonight,
I'd like to fool with my baby tonight,
Break ev'ry rule with my baby tonight,
But, pillow, you'll be my baby tonight,
 'Cause it's too darn hot.

REFRAIN I
According to the Kinsey Report
Ev'ry average man you know
Much prefers to play his favorite sport
When the temperature is low,
But when the thermometer goes 'way up
And the weather is sizzling hot,
Mister Adam
For his madam,
Is not,
'Cause it's too, too,
Too darn hot,
It's too darn hot,
It's too darn hot.

VERSE 2
It's too darn hot,
It's too darn hot.
I'd like to call on my baby tonight,

And give my all to my baby tonight,
I'd like to call on my baby tonight,
And give my all to my baby tonight,
But I can't play ball with my baby tonight,
'Cause it's too darn hot.

It's too darn hot,
It's too darn hot.
I'd like to meet with my baby tonight,
Get off my feet with my baby tonight,
I'd like to meet with my baby tonight,
Get off my feet with my baby tonight,
But no repeat with my baby tonight,
'Cause it's too darn hot.

It's too darn hot,
It's too darn hot.
I'd like to coo with my baby tonight,
And pitch some woo with my baby tonight,
I'd like to coo with my baby tonight,
And pitch some woo with my baby tonight,
But, brother, you bite my baby tonight,
'Cause it's too darn hot.

REFRAIN 2
According to the Kinsey Report
Ev'ry average man you know
Much prefers to play his favorite sport
When the temperature is low,
But when the thermometer goes 'way up
And the weather is sizzling hot,
Mister Gob

For his squab,
A marine
For his queen,
A G.I.
For his cutie-pie
Is not,
'Cause it's too, too,
Too darn hot,
It's too darn hot.
It's too, too, too, too darn hot.

Where Is the Life That Late I Led?

VERSE

Since I reached the charming age of puberty
And began to finger feminine curls,
Like a show that's typically Shuberty
I have always had a multitude of girls,
But now that a married man, at last, am I,
How aware of my dear, departed past am I.

REFRAIN I

Where is the life that late I led?
Where is it now? Totally dead.
Where is the fun I used to find?
Where has it gone? Gone with the wind.
A married life may all be well,
But raising an heir
Could never compare

With raising a bit of hell,
So I repeat what first I said,
Where is the life that late I?

In dear Milano, where are you, Momo,
Still selling those pictures of the Scriptures in the
 Duomo?
And, Carolina, where are you, Lina,
Still peddling your pizza in the streets o' Taormina?
And in Firenze, where are you, Alice,
Still there in your pretty, itty-bitty Pitti Palace?
And sweet Lucretia, so young and gay-ee?
What scandalous doin's in the ruins of Pompeii!

REFRAIN 2
Where is the life that late I led?
Where is it now? Totally dead.
Where is the fun I used to find?
Where has it gone? Gone with the wind.
The marriage game is quite all right,
Yes, during the day
It's easy to play,
But, oh, what a bore at night,
So I repeat what first I said,
Where is the life that late I?

PATTER 2
Where is Rebecca, my Becki-weckio,
Again is she cruising that amusing Ponte Vecchio?
Where is Fedora, the wild virago?

It's lucky I missed her gangster sister from Chicago.
Where is Venetia, who loved to chat so,
Could still she be drinkin' in her stinkin' pink palazzo?
And lovely Lisa, where are you, Lisa?
You gave a new meaning to the leaning tow'r of Pisa.

REFRAIN 3
Where is the life that late I led?
Where is it now? Totally dead.
Where is the fun I used to find?
Where has it gone? Gone with the wind.
I've oft been told of nuptial bliss,
But what do you do,
A quarter to two,
With only a shrew to kiss?
So I repeat what first I said,
Where is the life that late I led?

Always True to You in My Fashion

VERSE
Oh, Bill,
Why can't you behave,
Why can't you behave?
How in hell can you be jealous
When you know, baby, I'm your slave?
I'm just mad for you,
And I'll always be,
But naturally

If a custom-tailored vet
Asks me out for something wet,
When the vet begins to pet, I cry "Hooray!"
But I'm always true to you, darlin', in my fashion,
Yes, I'm always true to you, darlin', in my way.
I enjoy a tender pass
By the boss of Boston, Mass.,
Though his pass is middle-class and notta Backa Bay.
But I'm always true to you, darlin', in my fashion,
Yes, I'm always true to you, darlin', in my way.
There's a madman known as Mack
Who is planning to attack,
If his mad attack means a Cadillac, okay!
But I'm always true to you, darlin', in my fashion,
Yes, I'm always true to you, darlin', in my way.

I've been asked to have a meal
By a big tycoon in steel,
If the meal includes a deal, accept I may.
But I'm always true to you, darlin', in my fashion,
Yes, I'm always true to you, darlin', in my way.
I could never curl my lip
To a dazzlin' diamond clip,
Though the clip meant "let 'er rip," I'd not say "Nay!"
But I'm always true to you, darlin', in my fashion,
Yes, I'm always true to you, darlin', in my way.
There's an oil man known as Tex
Who is keen to give me checks,
And his checks, I fear, mean that sex is here to stay!

But I'm always true to you, darlin', in my fashion,
Yes, I'm always true to you, darlin', in my way.

There's a wealthy Hindu priest
Who's a wolf, to say the least,
When the priest goes too far east, I also stray.
But I'm always true to you, darlin', in my fashion,
Yes, I'm always true to you, darlin', in my way.
There's a lush from Portland, Ore.,
Who is rich but sich a bore,
When the bore falls on the floor, I let him lay.
But I'm always true to you, darlin', in my fashion,
Yes, I'm always true to you, darlin', in my way.
Mister Harris, plutocrat,
Wants to give my cheek a pat,
If the Harris pat
Means a Paris hat,
Bébé, Oo-la-la!
Mais je suis toujours fidèle, darlin', in my fashion,
Oui, je suis toujours fidèle, darlin', in my way.

From Ohio Mister Thorne
Calls me up from night 'til morn,
Mister Thorne once cornered corn and that ain't hay.
But I'm always true to you, darlin', in my fashion,
Yes, I'm always true to you, darlin', in my way.
From Milwaukee, Mister Fritz
Often moves me to the Ritz,
Mister Fritz is full of Schlitz and full of play.
But I'm always true to you, darlin', in my fashion,

Yes, I'm always true to you, darlin', in my way.
Mister Gable, I mean Clark,
Wants me on his boat to park,
If the Gable boat
Means a sable coat,
Anchors aweigh!
But I'm always true to you, darlin', in my fashion,
Yes, I'm always true to you, darlin', in my way.

Brush Up Your Shakespeare

VERSE

The girls today in society
Go for classical poetry,
So to win their hearts one must quote with ease
Aeschylus and Euripides.
One must know Homer and, b'lieve me, Bo,
Sophocles, also Sappho-ho.
Unless you know Shelley and Keats and Pope,
Dainty debbies will call you a dope.
But the poet of them all
Who will start 'em simply ravin'
Is the poet people call
The bard of Stratford-on-Avon.

REFRAIN I

Brush up your Shakespeare,
Start quoting him now.
Brush up your Shakespeare
And the women you will wow.

Just declaim a few lines from "Othella"
And they'll think you're a helluva fella.
If your blonde won't respond when you flatter 'er
Tell her what Tony told Cleopaterer,
 If she fights when her clothes you are mussing,
What are clothes? "Much Ado About Nussing."
Brush up your Shakespeare
And they'll all kowtow.

REFRAIN 2
Brush up your Shakespeare,
Start quoting him now.
Brush up your Shakespeare
And the women you will wow.
With the wife of the British embessida
Try a crack out of "Troilus and Cressida,"
If she says she won't buy it or tike it
Make her tike it, what's more, "As You Like It."
If she says your behavior is heinous
Kick her right in the "Coriolanus."
Brush up your Shakespeare
And they'll all kowtow.

REFRAIN 3
Brush up your Shakespeare,
Start quoting him now.
Brush up your Shakespeare
And the women you will wow.
If you can't be a ham and do "Hamlet"
They will not give a damn or a damnlet.
Just recite an occasional sonnet

And your lap'll have "Honey" upon it.
When your baby is pleading for pleasure
Let her sample your "Measure for Measure."
Brush up your Shakespeare
And they'll all kowtow.

REFRAIN 4
Brush up your Shakespeare,
Start quoting him now.
Brush up your Shakespeare
And the women you will wow.
Better mention "The Merchant of Venice"
When her sweet pound o' flesh you would menace.
If her virtue, at first, she defends—well,
Just remind her that "All's Well That Ends Well."
And if still she won't give you a bonus
You know what Venus got from Adonis!
Brush up your Shakespeare
And they'll all kowtow.

REFRAIN 5
Brush up your Shakespeare
Start quoting him now.
Brush up your Shakespeare
And the women you will wow.
If your goil is a Washington Heights dream
Treat the kid to "A Midsummer Night's Dream."
If she then wants an all-by-herself night
Let her rest ev'ry 'leventh or "Twelfth Night."
If because of your heat she gets huffy
Simply play on and "Lay on, Macduffy!"

Brush up your Shakespeare
And they'll all kowtow,
We trow, and they'll all kowtow.

GRAND FINALE
Brush up your Shakespeare,
Start quoting him now.
Brush up your Shakespeare
And the women you will wow.
So tonight just recite to your matey,
"Kiss me, Kate, kiss me, Kate, kiss me, Katey."
Brush up your Shakespeare
And they'll all kowtow.

Use Your Imagination

VERSE
What is, what is this song?
What can it be?
I wonder why
It seems to apply
To me.

REFRAIN
Use your imagination,
Just take this motto for your theme
And soon ev'ry night
Will be crowded with delight
And ev'ry day will be a dream.

Use your imagination,
You'll see such wonders if you do.
Around you there lies
Pure enchantment in disguise
And endless joys you never knew.
Behind ev'ry cloud
There's a so lovely star,
Behind ev'ry star
There's a lovelier one by far,
So use your imagination,
Just take this motto for your theme
And soon you will dance
On the road to sweet romance
And ev'ry day will be a dream.

2ND ENDING
And ev'ry day will be a perfect dream.

I Am Loved

VERSE
Yesterday was a dull day,
Yesterday was a gray day,
But, oh, today,
Today is a gay day.
You ask me, darling, why?
And I answer:

I am loved,
I am loved
By the one I love in ev'ry way.
I am loved,
Absolutely loved,
What a wonderful thing to be able to say.
I'm adored,
I'm adored
By the one who first led my heart astray.
I'm adored,
Absolutely adored,
What a wonderful thing to be able to say.
So ring out the bells
And let the trumpets blow
And beat on the drums,
For now I know, I know
I am loved,
I am loved,
What a wonderful thing,
What a glorious thing,
What a beautiful thing to be able to say.

They Couldn't Compare to You

VERSE

MERCURY: Oh, what a bevy of beauties,
 Oh, what a school of fish,
 Oh, what a covey of cuties,

Oh, what a dish delish!
I've known but litters of minxes,
All of 'em fun for a while,
Yet now, for the nonce, what methinks is,
You've got 'em

GIRLS: We've got 'em

ALL: Beat a mile.

REFRAIN 1

MERCURY: They couldn't compare to you,
They couldn't compare to you,
Although I've played
Many, many a maid,
They couldn't compare to you.
I've thoroughly pitched the woo,
From the heights of Valhalla to Kalamazoo,
And though they all
Had a lot on the ball,
They couldn't compare to you.
Of ladies fair,
I've loved more than my share,
And strange but true,
I hereby declare,
From tiptoe to hair,
They could not compare
To you.

PATTER

I attended *Call Me Madam*
And shortly began to nestle Essel Merman.
I admired the silken body

Of the chic Scheherazade,
Then of Lady Godiva I became the lord.
After that I staged an orgy
For some friends o' Lucretia Borgie,
And ended up at the Stork with Fanny Ward.
After having had a party
With Phoenicia's goddess Astarte,
Well, I raised a bit of hell with Penelope.
After quieting all my urgin's
For several Vestal Virgins,
I put on a strip for Gypsy Rose Lee.
Though I liked the Queen of Sheba,
She was mentally an amoeba.
As for Beatrice d'Este,
She was a pest and far too chesty.
As for the passionate wife of Nero,
My reaction was frankly zero.
As for that sorceress known as Circe,
She was so hot I hollered for mercy!

GIRLS: So hot he hollered for mercy!

MERCURY: There was Galatea,
And mean Medea,
And Sappho, one of the best.
There was Nefertiti,
A perfect sweetie,
And gay Mae West.
I was a helluva fella
With Cinderella
And Isabella of Spain.
And I used to caress
Both Lola Montez
And that damn Calamity Jane.

When betwixt Nell Gwyn
And Anne Boleyn
I was forced to make my choice,
I became so confused
I was even amused
And abused by Peggy Joyce.
There was Mélisande,
A platinum blonde
(How I loved to ruffle her locks).
There was bright Aurora,
Then Pandora,
Who let me open her box!

REFRAIN 2

GIRLS:	They couldn't compare to us,
MERCURY:	They couldn't compare to you,
GIRLS:	Although he's played
	Many, many a maid,
MERCURY:	They couldn't compare to you.
	I've thoroughly pitched the woo,
	From Galli-pippo-lippy to Tippecanœ
GIRLS:	And though they all
	Had a lot on the ball,
MERCURY:	They couldn't compare to you.
	Of ladies fair,
	I've loved more than my share,
GIRLS:	And strange but true,
MERCURY:	I hereby declare,
	From tiptoe to hair,
GIRLS:	From hep cat to square,
MERCURY:	From dressed-up to bare,
	They could not compare,
	To you.

Nobody's Chasing Me

The breeze is chasing the zephyr,
The moon is chasing the sea,
The bull is chasing the heifer,
But nobody's chasing me.
The cock is chasing the chicken,
The pewee, some wee pewee,
The cat is taking a lickin',
But nobody's taking me.
Nobody wants to own me,
And I object.
Nobody wants to phone me,
Even collect.
The leopard's chasing the leopard,
The chimp, some champ chimpanzee,
The sheep is chasing the shepherd,
But nobody's chasing me.
Nobody,
Nobody's chasing me.

The flood is chasing the levee,
The wolf is out on a spree,
The Ford is chasing the Chevy,
But nobody's chasing me.
The bee is chasing Hymettus,
The queen is chasing the bee,
The worm is chasing the lettuce,
But nobody's chasing me.

Each night I get the mirror
From off the shelf.
Each night I'm getting queerer,
Chasing myself.
Ravel is chasing Debussy,
The aphis chases the pea,
The gander's chasing the goosey,
But nobody's goosing me.
Nobody,
Nobody's chasing me.

REFRAIN 3
The rain's pursuing the roses,
The snow, the trim Christmas tree,
Big dough pursues Grandma Moses,
But no one's pursuing me.
While Isis chases Osiris,
And Pluto, Proserpine.
My doc is chasing my virus,
But nobody's chasing me.
I'd like to learn canasta
Yet how can I?
What wife without her masta
Can multiply?
The clams are almost a-mixin',
The hams are chasing TV,
The fox is chasing the vixen,
But nobody's vixin' me.
Nobody,
Nobody's chasing me.

The llama's chasing the llama,
Papa is chasing Mama,
Monsieur is chasing Madame,
But nobody's chasing moi.
The dove, each moment, is bolda,
The lark sings, "Ich liebe dich,"
Tristan is chasing Isolda,
But nobody's chasing mich.
Although I may be Juno,
B'lieve it or not,
I've got a lot of you-know,
And you know what!
The snake with passion is shakin',
The pooch is chasing the flea,
The moose his love call is makin'
[*Sung with head cold*]
But dobody's baki'd be.
Dobody [*sneeze*],
Nobody's chasing me.

From This Moment On

VERSE

Now that we are close,
No more nights morose,
Now that we are one,
The beguine has just begun.
Now that we're side by side,

The future looks so gay,
Now we are alibi-ed
When we say:

REFRAIN
From this moment on,
You for me, dear,
Only two for tea, dear,
From this moment on.
From this happy day,
No more blue songs,
Only whoop-dee-doo songs,
From this moment on.
For you've got the love I need so much,
Got the skin I love to touch,
Got the arms to hold me tight,
Got the sweet lips to kiss me good night.
From this moment on,
You and I, babe,
We'll be ridin' high, babe,
Ev'ry care is gone
From this moment on.

I Am in Love

VERSE
Sit down, mad'moiselle,
And from laughing refrain.
Sit down, mad'moiselle,

And, I beg you, try
To listen while I
Explain.

REFRAIN
I am dejected,
I am depressed,
Yet resurrected
And sailing the crest.
Why this elation,
Mixed with deflation?
What explanation?
I am in love!
Such conflicting questions ride
Around in my brain,
Should I order cyanide
Or order champagne?
Oh, what is this sudden jolt?
I feel like a frighten'd colt
Just hit by a thunderbolt,
I am in love!
I knew the odds
Were against me before,
I had no flair
For flaming desire,
But since the gods
Gave me you to adore,
I may lose
But I refuse to fight the—fire!
So come and enlighten my days

And never depart.
You only can brighten the blaze
That burns in my heart,
For I am wildly in love with you,
And so in need of
A stampede of
Love!

It's All Right With Me

It's the wrong time and the wrong place,
Though your face is charming, it's the wrong face,
It's not her face but such a charming face
That it's all right with me.
It's the wrong song in the wrong style,
Though your smile is lovely, it's the wrong smile,
It's not her smile but such a lovely smile
That it's all right with me.
You can't know how happy I am that we met,
I'm strangely attracted to you.
There's someone I'm trying so hard to forget,
Don't you want to forget someone too?
It's the wrong game with the wrong chips,
Though your lips are tempting, they're the wrong lips,
They're not her lips but they're such tempting lips
That if some night you're free,
Dear, it's all right,
It's all right
With me.

Can-Can

VERSE
Ev'rybody,
Chic or shoddy,
Ev'rybody loves to dance
Since that big dance,
Infra-dig dance
Called the "can-can" captivated France.
Why does it kill ev'ry care?
Why is it done ev'rywhere?

REFRAIN 1
There is no trick to a can-can,
It is so simple to do,
When you once kick to a can-can,
'Twill be so easy for you.
If a lady in Iran can,
If a shady African can,
If a Jap with a slap of her fan can,
Baby, you can can-can too.
If an English Dapper Dan can,
If an Irish Callahan can,
If an Afghan in Afghanistan can,
Baby, you can can-can too.

REFRAIN 2
If in Deauville ev'ry swell can,
It is so simple to do,
If Debussy and Ravel can,
'Twill be so easy for you.

If the Louvre custodian can,
If the Guard Republican can,
If Van Gogh and Matisse and Cézanne can,
Baby, you can can-can too.
If a chief in the Sudan can,
If the hefty Aga Khan can,
If the camels in his caravan can,
Baby, you can can-can too.

Takes no art to do a can-can,
It is so simple to do,
When you start to do a can-can,
'Twill be so easy for you.
If a slow Mohammedan can,
If a kilted Scottish clan can,
If in Wagner a Valkyrian can,
Baby, you can can-can too.
If a lass in Michigan can,
If an ass in Astrakhan can,
If a bass in the Saskatchewan can,
Baby, you can can-can too.

If the waltz king Johann Strauss can,
It is so simple to do,
If his gals in *Fledermaus* can,
'Twill be so easy for you.
Lovely Duse in Milan can,
Lucien Guitry and Réjane can,
Sarah Bernhardt upon a divan can,

Baby, you can can-can too.
If a holy Hindu man can,
If a gangly Anglican can,
If in Lesbos, a pure Lesbian can,
Baby, you can can-can too.

REFRAIN 5
If an ape gargantuan can,
It is so simple to do,
If a clumsy pelican can,
'Twill be so easy for you.
If a dachshund in Berlin can,
If a tomcat in Pekin can,
If a crowded sardine in a tin can,
Baby, you can can-can too.
If a rhino with a crash can,
If a hippo with a splash can,
If an elm and an oak and an ash can,
Baby, you can can-can too.

Who Said Gay Paree?

REFRAIN
Who spread the rumor Paris was fun?
Who had such fantasy?
Who never knew
Paris minus you?
Who said Gay Paree?
Who said, of all towns under the sun,
All lovers here should be?

Who failed to add
Paris could be sad?
Who said Gay Paree?
I thought our love, so brightly begun,
Would burn through eternity.
Who told the lie,
Love can never die?
Who said Gay Paree,
Who said Gay Paree?

I Love Paris

VERSE

Ev'ry time I look down
On this timeless town,
Whether blue or gray be her skies,
Whether loud be her cheers
Or whether soft be her tears,
More and more do I realize

REFRAIN

I love Paris in the springtime,
I love Paris in the fall,
I love Paris in the winter, when it drizzles,
I love Paris in the summer, when it sizzles,
I love Paris ev'ry moment,
Ev'ry moment of the year.
I love Paris,
Why, oh, why do I love Paris?
Because my love is near.

All of You

VERSE

After watching your appeal from ev'ry angle,
There's a big romantic deal I've got to wangle,
For I've fallen for a certain luscious lass
And it's not a passing fancy or a fancy pass.

REFRAIN

I love the looks of you, the lure of you,
I'd love to make a tour of you,
The eyes, the arms, the mouth of you,
The east, west, north, and the south of you.
I'd love to gain complete control of you,
And handle even the heart and soul of you,
So love, at least, a small percent of me, do,
For I love all of you.

Stereophonic Sound

REFRAIN I

Today to get the public to attend a picture show,
It's not enough to advertise a famous star they know.
If you want to get the crowds to come around
You've got to have glorious Technicolor,
Breathtaking Cinemascope and
Stereophonic sound.
If Zanuck's latest picture were the good old-fashioned
 kind,
There'd be no one in front to look at Marilyn's behind.

If you want to hear applauding hands resound
You've got to have glorious Technicolor,
Breathtaking Cinemascope and
Stereophonic sound.
The customers don't like to see the groom embrace the
 bride
Unless her lips are scarlet and her bosom's five feet wide.
You've got to have glorious Technicolor,
Breathtaking Cinemascope or
Cinerama, VistaVision, Superscope or Todd-A-O and
Stereophonic sound,
And stereophonic sound.

REFRAIN 2
You all remember Lassie, that beloved canine star.
To see her wag her tail the crowds would come from
 near and far,
But at present she'd be just another hound
Unless she had glorious Technicolor,
Breathtaking Cinemascope and
Stereophonic sound.
I lately did a picture at the bottom of the sea—
I rassled with an octopus and licked an anchovee,
But the public wouldn't care if I had drowned
Unless I had glorious Technicolor,
Breathtaking Cinemascope and
Stereophonic sound.
If Ava Gardner played Godiva riding on a mare
The people wouldn't pay a cent to see her in the bare
Unless she had glorious Technicolor,
Cinecolor or
Warnercolor or

Pathécolor or
Eastmancolor or
Kodacolor or
Any color and
Stereophonic sound,
And stereophonic,
As an extra tonic,
Stereophonic sound.

Siberia

REFRAIN I

When we're sent to dear Siberia,
To Siberi-eri-a,
When it's cocktail time 'twill be so nice
Just to know you'll not have to phone for ice.
When we meet in sweet Siberia,
Far from Bolshevik hysteria,
We'll go on a tear,
For our buddies all are there
In cheery Siberi—a.

REFRAIN 2

When we're sent to dear Siberia,
To Siberi-eri-a,
Where they say all day the sun shines bright,
And they also say that it shines all night,
The aurora borealis is
Not as heated as a palace is.

If on heat you dote
You can shoot a sable coat
In cheery Siberi—a.

When we're sent to dear Siberia,
To Siberi-eri-a,
Where the labor laws are all so fair
That you never have unemployment there,
When we meet in sweet Siberia
To protect us from diphtheria,
We can toast our toes
On the lady Eskimos
In cheery Siberi—a.

When we're sent to dear Siberia,
To Siberi-eri-a,
Since the big salt mines will be so near,
We can all have salt to put in our beer,
When we meet in sweet Siberia,
Where the snow is so superia
You can bet, all right
That your Christmas will be white
In cheery Siberi—a.

You're Sensational

A thorough knowledge I've got about girls,
I've been around.
And after learning a lot about girls,
This is the important fact I found:

REFRAIN I
I've no proof
When people say you're more or less aloof,
But you're sensational.
I don't care
If you are called "The Fair Miss Frigid Air,"
'Cause you're sensational.
Making love is quite an art,
What you require is the proper squire to fire your heart,
And if you say
That one fine day you'll let me come to call,
We'll have a ball,
'Cause you're sensational,
Sensational,
That's all, that's all, that's all.

VERSE 2
A thorough knowledge I've got about boys,
I've been around.
And after learning a lot about boys,
This is the important fact I found:

I've no proof
When people say you're more or less aloof,
But you're sensational.
I don't care
If you are known as "Mister Frigid Air,"
'Cause you're sensational.
Making love is quite an art,
What you should meet is a maiden sweet to heat your
 heart.
And if you say
That one fine day you'll like to come and call,
We'll have a ball,
'Cause you're sensational,
Sensational,
That's all, that's all, that's all.

BIOGRAPHICAL NOTE

COPYRIGHTS & PUBLICATION INFORMATION

INDEX OF TITLES

BIOGRAPHICAL NOTE

Cole Porter was born in June 19, 1891, in Peru, Indiana. He began composing songs at age ten. He attended Yale, where he wrote many of the school's football songs and several musical comedies. After graduating in 1913, he toured Europe; afterwards he entered Harvard Law School before transferring to Harvard School of Music. His songs, for which he wrote both music and lyrics, began appearing in Broadway musicals in 1915, and his first Broadway show, *See America First*, opened the following year. In 1917 he sailed to France to serve the Duryea Relief Organization; in 1919 he married Linda Lee Thomas, and they moved into her house in Paris. In subsequent years he contributed songs to numerous musicals—including *Paris* (1928), *The New Yorkers* (1930), *Gay Divorce* (1932), *Anything Goes* (1934), *Red, Hot and Blue* (1936), and *Du Barry Was a Lady* (1939)—and traveled frequently in Europe. He wrote the score for the film *Born to Dance* (1936) in Hollywood. In a riding accident in 1937 his legs were crushed, and he later underwent over 30 operations to avoid amputation. His later musicals included *Panama Hattie* (1940), *Let's Face It* (1941), *Mexican Hayride* (1944), *Kiss Me, Kate* (1948), *Out of This World* (1950), *Can-Can* (1953), and *Silk Stockings* (1955); he also wrote the scores for the films *High Society* (1956) and *Les Girls* (1957). He died on October 15, 1964.

SONG COPYRIGHTS AND PUBLICATION INFORMATION

The texts in this volume are taken from *The Complete Lyrics of Cole Porter*, edited by Robert Kimball (New York: Knopf, 1983). For all songs copyrights: All rights reserved. International copyrights secured.

Bull Dog. Written at Yale, fall 1911. Copyright © 1971 by John F. Wharton, as Trustee. Reprinted with permission.

Antoinette Birby. Written at Yale. Copyright © 1971 by John F. Wharton, as Trustee. Reprinted with permission.

I've a Shooting Box in Scotland. Performed at sole performance of Yale show *Paranoia*, April 24, 1914. Included in *See America First* (1916). Published February 1916.

War Song. Parody of "They Didn't Believe Me," song by Jerome Kern and Herbert Reynolds (M. E. Rourke) written for the American version of the musical *The Girl from Utah* (1914). Copyright © 1971 by John F. Wharton, as Trustee. Reprinted with permission.

Old-Fashioned Garden. From *Hitchy-Koo of 1919* (1919). Published August 1919.

When I Had a Uniform On. From *Hitchy-Koo of 1919* (1919). Published August 1919.

Two Little Babes in the Wood. Dropped from *Greenwich Village Follies* (1924), the song was included, without the two "Announcement" sections, in *Paris* (1928). Published February 1928. Copyright © 1928 (renewed) Warner Bros. Inc. Reprinted with permission.

I'm In Love Again. Added to *Greenwich Village Follies* (1924) after its New York opening. Published June 1925. Copyright © 1925 (renewed) Warner Bros. Inc. Reprinted with permission.

Let's Misbehave. Dropped and replaced by "Let's Do It, Let's Fall in Love" in *Paris* (1928); published June 1927. Copyright © 1927 (renewed) Warner Bros. Inc. Reprinted with permission.

The Laziest Gal in Town. Published June 1927. Copyright © 1927 (renewed) Warner Bros. Inc. Reprinted with permission.

Weren't We Fools? Written for Fanny Brice to sing in her vaudeville act in November 1927; according to Porter, it had been written several years earlier. Published November 1927. Copyright © 1927 (renewed) Warner Bros. Inc. Reprinted with permission.

Let's Do It, Let's Fall In Love. Replaced "Let's Misbehave" in *Paris* (1928). Published October 1928. Refrain's phrase "Chinks do it, Japs do it" was changed to "birds do it, bees do it." Published October 1928. Copyright © 1928 (renewed) Warner Bros. Inc. Reprinted with permission.

Which? Dropped before the New York opening of *Paris* (1928) and included under the title "Which Is the Right Life" in *Wake Up and Dream* (1929). Published February 1928. Copyright © 1928 (renewed) Warner Bros. Inc. Reprinted with permission.

Wake Up and Dream. From *Wake Up and Dream* (1929). Published March 1929. Copyright © 1929 (renewed) Warner Bros. Inc. Reprinted with permission.

Looking at You. From *Wake Up and Dream* (1929). Published March 1929. Copyright © 1929 (renewed) Warner Bros Inc. Reprinted with permission.

What Is This Thing Called Love? From *Wake Up and Dream* (1929). Published March 1929. Copyright © 1929 (renewed) Warner Bros. Inc. Reprinted with permission.

I'm a Gigolo. From *Wake Up and Dream* (1929), added two weeks into the original London production. Published May 1929. Copyright © 1929 (renewed) Warner Bros. Inc. Reprinted with permission.

You Do Something to Me. From *Fifty Million Frenchmen* (1929). Published November 1929. Copyright © 1929 (renewed) Warner Bros. Inc. Reprinted with permission.

You've Got That Thing. From *Fifty Million Frenchmen* (1929). Published December 1929, without Refrain 3, which appears in a manuscript of the song. Copyright © 1929 (renewed) Warner Bros. Inc. Reprinted with permission.

The Tale of the Oyster. From *Fifty Million Frenchmen* (1929), which opened in New York on November 27, 1929; by January 1930, however, the song had been dropped from the show. Variant of song "The Scampi" written for the amusement of his friends in Venice. Not published until *The Unpublished Cole Porter* (1975). Copyright © 1966 by John F. Wharton, as Trustee. Reprinted with permission.

You Don't Know Paree. From *Fifty Million Frenchmen* (1929). Published December 1929. Copyright © 1929 (renewed) Warner Bros. Inc. Reprinted with permission.

I'm Unlucky at Gambling. From *Fifty Million Frenchmen* (1929). Published December 1929, without Verse 2, which was sung in the show. Copyright © 1929 (renewed) Warner Bros. Inc. Reprinted with permission.

I Worship You. Performed in Boston tryouts for *Fifty Million Frenchmen* (1929) but dropped before the show's opening in New York. Published November 1929. Copyright © 1929 (renewed) Warner Bros. Inc. Reprinted with permission.

The Queen of Terre Haute. Performed in Boston tryouts for *Fifty Million Frenchmen* (1929) but dropped before the show's opening in New York. Published November 1929. Copyright © 1929 (renewed) Warner Bros. Inc. Reprinted with permission.

Why Don't We Try Staying Home? Dropped during rehearsals of *Fifty Million Frenchmen* (1929). Not published until *The Unpublished Cole Porter* (1975). Copyright © 1966 by John F. Wharton, as Trustee. Reprinted with permission.

Love for Sale. From *The New Yorkers* (1930). Published November 1930. Copyright © 1930 (renewed) Warner Bros. Inc. Reprinted with permission.

I Happen to Like New York. From *The New Yorkers* (1930). Published March 1931. Copyright © 1931 (renewed) Warner Bros. Inc. Reprinted with permission.

After You, Who? From *Gay Divorce* (1932). Published November 1932. Copyright © 1932 (renewed) Warner Bros. Inc. Reprinted with permission.

Night and Day. From *Gay Divorce* (1932). Published November 1932. Copyright © 1932 (renewed) Warner Bros. Inc. Reprinted with permission.

I've Got You on My Mind. From *Gay Divorce* (1932). Published November 1932. Apparently the song was to be included in *The New Yorkers* and the unproduced show *Star Dust* (1931). Copyright © 1932 (renewed) Warner Bros. Inc. Reprinted with permission.

Mister and Missus Fitch. From *Gay Divorce* (1932). First intended for unproduced *Star Dust*. Published 1954, with "witch" and "son of the rich" substituted in the final lines for "bitch" and "son of a bitch," which were sung in *Gay Divorce*. Sheet music for the percussion part for *Gay Divorce* contain instructions to drown out "bitch" and "son of a bitch." Copyright © 1954 (renewed) Warner Bros. Inc. Reprinted with permission.

The Physician. From *Nymph Errant* (1933). Under the title "But He Never Says He Loves Me," performed in *The New Yorkers* before it

opened in New York; intended as well for *Star Dust*. Published September 1933. Copyright © 1933 (renewed) Warner Bros. Inc. Reprinted with permission.

Miss Otis Regrets. From London production of *Hi Diddle Diddle* (1934). Published April 1934. Copyright © 1934 (renewed) Warner Bros. Inc. Reprinted with permission.

I Get a Kick Out of You. From *Anything Goes* (1934). Originally intended for unproduced *Star Dust*. Published November 1934. Copyright © 1934 (renewed) Warner Bros. Inc. Reprinted with permission.

All Through the Night. From *Anything Goes* (1934). Published November 1934; several lines here not in that version are added from the script and from manuscripts. Copyright © 1934 (renewed) Warner Bros. Inc. Reprinted with permission.

You're the Top. From *Anything Goes* (1934). Published November 1934. The parodic lines included here are by Irving Berlin. Copyright © 1934 (renewed) Warner Bros. Inc. Reprinted with permission.

Anything Goes. From *Anything Goes* (1934). Published November 1934. The sequence of the refrains was altered throughout Porter's career. Copyright © 1934 (renewed) Warner Bros. Inc. Reprinted with permission.

Blow, Gabriel, Blow. From *Anything Goes* (1934). Published November 1934. Copyright © 1934 (renewed) Warner Bros. Inc. Reprinted with permission.

Thank You So Much, Mrs. Lowsborough-Goodby. Possibly originally meant for *Anything Goes* but not included in the show. Published December 1934. Copyright © 1934 (renewed) Warner Bros. Inc. Reprinted with permission.

Don't Fence Me In. Lyric based on a poem by Robert Fletcher. Written for an unproduced film that was to be called *Adios, Argentina* (1934–35). It was sung in the movie *Hollywood Canteen* (1944). Published October 1944. Copyright © 1944 (renewed) Warner Bros. Inc. Reprinted with permission.

Begin the Beguine. From *Jubilee* (1935). Published October 1935. The penultimate line originally read "the sweetness of sin" for "what heaven we're in." Copyright © 1935 (renewed) Warner Bros. Inc. Reprinted with permission.

Just One of Those Things. From *Jubilee* (1935). Published October 1935. Copyright © 1935 (renewed) Warner Bros. Inc. Reprinted with permission.

Easy to Love. From *Born to Dance* (1936), although it was originally written for *Anything Goes*. Published September 1936. Copyright © 1936 by Chappell & Co., Inc. Copyright renewed. Reprinted with permission.

I Concentrate on You. From *Broadway Melody of 1940* (1939). Published December 1939. Copyright © 1939 by Chappell & Co., Inc. Copyright renewed. Assigned to John F. Wharton, Trustee of the Cole Porter Musical & Literary Property Trusts. Chappell & Co., Inc., Publisher. International Copyright Secured. All Rights Reserved. Reprinted with permission.

But in the Morning, No. From *Du Barry Was a Lady* (1939). Published November 1939. Copyright © 1939 by Chappell & Co., Inc. Copyright renewed. Assigned to John F. Wharton, Trustee of the Cole Porter Musical & Literary Property Trusts. Chappell & Co., Inc., Publisher. International Copyright Secured. All Rights Reserved. Reprinted with permission.

Well, Did You Evah! From *Du Barry Was a Lady* (1939). Published January 1940. Copyright © 1940 by Chappell & Co., Inc. Copyright renewed. Assigned to John F. Wharton, Trustee of the Cole Porter Musical & Literary Property Trusts. Chappell & Co., Inc., Publisher. International Copyright Secured. All Rights Reserved. Reprinted with permission.

Katie Went to Haiti. From *Du Barry Was a Lady* (1939). Published November 1939. Copyright © 1939 by Chappell & Co., Inc. Copyright renewed. Assigned to John F. Wharton, Trustee of the Cole Porter Musical & Literary Property Trusts. Chappell & Co., Inc., Publisher. International Copyright Secured. All Rights Reserved. Reprinted with permission.

I've Still Got My Health. From *Panama Hattie* (1940). Published October 1940. Copyright © 1940 by Chappell & Co., Inc. Copyright renewed. Assigned to John F. Wharton, Trustee of the Cole Porter Musical & Literary Property Trusts. Chappell & Co., Inc., Publisher. International Copyright Secured. All Rights Reserved. Reprinted with permission.

I'm Throwing a Ball Tonight. From *Panama Hattie* (1940). Not published until *The Unpublished Cole Porter* (1975). Copyright © 1966 by John F. Wharton, as Trustee. Reprinted with permission.

Make It Another Old-Fashioned, Please. From *Panama Hattie* (1940). Published October 1940. Copyright © 1940 by Chappell & Co., Inc. Copyright renewed. Assigned to John F. Wharton, Trustee of the Cole Porter Musical & Literary Property Trusts. Chappell & Co., Inc., Publisher. International Copyright Secured. All Rights Reserved. Reprinted with permission.

Dream-Dancing. From *You'll Never Get Rich* (1941). Published July 1941. Copyright © 1941 by Chappell & Co., Inc. Copyright renewed. Assigned to John F. Wharton, Trustee of the Cole Porter Musical & Literary Property Trusts. Chappell & Co., Inc., Publisher.

INDEX OF TITLES

ABOUT THE PUBLISHER

Volumes in the American Poets Project series are published by Library of America, a nonprofit organization that champions the nation's cultural heritage by publishing America's greatest writing in authoritative new editions and providing resources for readers to explore this rich, living legacy. For a free catalog or to learn how you can help support Library of America's mission, please visit www.loa.org or write: Library of America, 14 East 60th Street, 11th Floor, New York, NY 10022.